IMAGES
*of America*

# FISHERS LANDING

D1452000

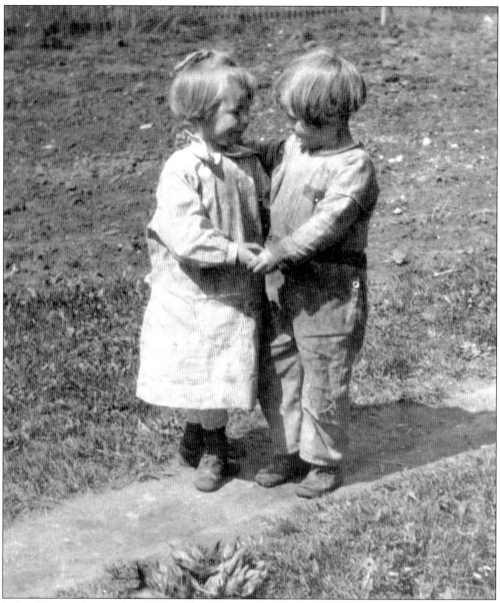

Infant Thomas Gentry, born in 1915, hugs his cousin Margaret Gentry on the Gentry farm, part of the William M. Simmons donation land claim. Thomas Gentry is the great-grandson of William M. Simmons and Ann Jemima Fisher. Ann Jemima's brother Solomon Welton Fisher, a farmer and businessman, built Fisher's Riverboat Landing on the Columbia River in 1851. (Courtesy Thomas E. Gentry collection.)

ON THE COVER: Fishers Quarry opened in the 1880s and became the primary supplier of Columbia basalt during construction of the jetty at the mouth of the Columbia River. These quarrymen, among them European immigrant laborers and many from Fishers Landing, work a quarry pit west of today's 192nd Avenue around 1910. Today the rock is nearly mined out. Redevelopment of the area into housing and shopping districts continues. (Courtesy Norman Powell.)

IMAGES
*of America*

# FISHERS LANDING

Richenda Fairhurst

ARCADIA
PUBLISHING

Published by Arcadia Publishing
Charleston SC, Chicago IL, Portsmouth NH, San Francisco CA

Printed in the United States of America

Library of Congress Catalog Card Number: 2007943440

For all general information contact Arcadia Publishing at:
Telephone 843-853-2070
Fax 843-853-0044
E-mail sales@arcadiapublishing.com
For customer service and orders:
Toll-Free 1-888-313-2665

Visit us on the Internet at www.arcadiapublishing.com

*To Thomas E. Gentry. In him, the past is made known, and the future is made possible.*

# CONTENTS

Acknowledgments                                         6

Introduction                                            7

1.  First People and Families                           9

2.  Life at Fishers and on the Plain                    43

3.  Founding a State                                    69

4.  Timber, Rock, Prunes, and Paper                     87

5.  Pioneer Schools Come of Age                         107

# ACKNOWLEDGMENTS

Many, many humble thank-yous to all those who contributed their time and knowledge to this history: Thomas E. Gentry; Norman Powell; Pat Forgey; Patsy Sleutel; Gene English; Bob Hitchcock Jr. and Sr.; Jeanette Arvidson; Jean Norwood; Betty Ramsay, director of the Two Rivers Heritage Museum in Washougal; museum officers Ceil Kirchner, Phil Harris, and Bev and Curtis Hughey; and all the wonderful museum volunteers. I am also grateful to the following: the staff at Union High School; the librarians at Fort Vancouver Library; Larry and Marilyn Bone and the Mill Plain United Methodist Church; Bob Richards of the Fishers Grange; Minnie Proctor; Greg and Donna Smith; Ed Reitan, Washington State secretary of the Independent Order of Odd Fellows (IOOF); Bob Lewis of the Columbia Vista Corporation; Chuck Rose of Rinker Corporation; and Lee Watkins of the Washington State Geological Library. A big hug and thank-you goes to my editor and champion, Julie Albright, and a special thank-you to Dory Brooking—the inspiration and impetus for this volume.

The bulk of the information in this book is drawn from personal interviews and oral histories. Useful print sources include the microfiche archives of the *Vancouver Independent* and *Daily Columbian*, available at the Fort Vancouver Public Library; *Clarke County Washington Territory 1885* by B. F. Alley and J. P. Munro-Fraser, available at the Two Rivers Heritage Museum; *Clark County Pioneers: A Centennial Salute* and *Clark County Pioneers through the Turn of the Century* by Rose Marie Harshmann; and several volumes of Fort Vancouver Historical Society periodicals, available at the Clark College Library. Thanks also go to the folks at the Washington State Archives for their online searchable databases. The portraits of Louis Van Vleet, Henry Pittock, and David Thompson are from Joseph Gaston's *City of Portland*, produced by Clarke Publishing in 1911.

# INTRODUCTION

Fishers Landing got its start when the Fisher siblings traveled west in 1851. There were three bachelor brothers—Solomon W., Adam, and Job—and their sisters Rachel, 17, and Ann Jemima, who was married to William Mortimer Simmons. Though minors at the time, two other Fisher boys—John C. and Michael—also may have come west.

Solomon Fisher and Ann Jemima Fisher (with her husband) took side-by-side donation land claims on the Columbia River. Combined, they owned almost 1,000 acres from today's Southeast Thirty-fourth Street south along 164th Avenue to the river and extending to Government Island. Schoolteacher Vida English noted that, in the beginning, the Simmons claim was thick with giant fir trees spaced wide enough apart that a horse and wagon could easily negotiate a path. It was a vast and beautiful parkland that bubbled with basalt boulders and clear, natural springs.

Solomon Fisher was a lifelong bachelor and shrewd businessman. As the British vamoosed to Canada, he set to work building a riverboat landing on the Colombia River and established a post office. His landing seeded a town called Fishers, a thriving and important center of the early Clark County community both commercially and politically. Solomon never married, but the longtime postmistress at Fishers more than made up for Solomon's reticence to engage in matrimony. She had an enthusiastic propensity toward the married state, and in an era where a woman could disappear into her married name, the four postmistresses of Fishers—Mrs. Buchanan, Mrs. Durbin, Mrs. Danforth, and Mrs. Cole—were all one and the same.

Adam and Job also took up land claims in the Fishers area. Adam Fisher owned a large tract in today's Cascade Park. Disliking the "citified" trend at Fishers, he moved to the Willamette Valley in the 1880s, married Elizabeth Dort, and raised children and ran a dairy farm. Job married and had two children. His son, also named Solomon W. Fisher, would inherit his uncle and father's land and businesses in 1905 when he was just 20 years old. Rachel Fisher married Henry Monroe Knapp, an individual at the center of territorial politics. The Knapps, well known and well respected, had six children together, though they lost three. Their neighbors included the Hickses, the Paynes, and the Lovelaces. One family built a hidden basement in a prune dryer in order to manufacture liquor during Prohibition.

Often it was the young people who came west, people in their 20s and 30s who were ready to take on the physical challenges of settling a homestead. Once they were settled, and especially after the railroad came in, their parents sometimes joined them in the new territory. May Simmons's grandmother was a cousin to Robert E. Lee. Her grandparents came west in 1879 and set up a farm in Fishers. One day when Grandmother Lee was alone on the farm, she went out to the smokehouse to cut down some meat. As she headed back to the house, out from the bushes stepped a large black bear. The gate was still ahead of her, and Grandmother Lee knew she had to get to the gate first. She steeled her nerves, got a good grip on her knife, and charged for the gate. The bear was quicker. It lunged to attack her. Grandmother Lee thrust up with the knife and, in an act she later ascribed to pure self-preservation, stabbed the bear multiple times, killing it. The Simmons family kept the bear's paw as an heirloom.

Fishers' heyday as a thriving river port diminished after the construction of the railroad in 1908, and by the time of the automobile, it had become a quiet riverside community of farmers and worker cabins. From the 1930s through the 1950s, many knew the area as Pumpkin Center. George Allen owned a general store and gas station at the bottom of today's 164th Avenue and named the store Pumpkin Center. He had high hopes for rekindling some of Fishers' old steam and tried to rename the region Pumpkin Center as well. The name, though well remembered, did not stick. As George Allen's wife reportedly said, "There aren't any pumpkins around here."

Today Fishers and Mill Plain are one and the same; however, this has only been true since the 1980s. Before that, Fishers Landing was divided into a number of districts, including the northern Harmony District, parts of the Lackamas (Lacamas) District to the east, west into what is today called Cascade Park, and Fishers, which stretched along the Columbia River from Camas to Ellsworth. The central portion was called Mill Plain, which bears a rich settlement history of its own starting with the Hudson's Bay Company.

In the 1830s, a Hudson's Bay village sat at the intersection of today's 164th Avenue and Mill Plain Boulevard in an area called Second Plain. There workers raised wheat for the company, grazed sheep and livestock, and raced horses along the dirt track. They also built and ran a sawmill and gristmill, the first such mills in Washington State, on the banks of the Columbia River at today's Ellsworth. The area's association with these mills caused Second Plain to be referred to instead as Mill Plain.

Among Mill Plain's earliest settled families were the Dubacks, whose landholdings included the Evergreen Airport; the Blairs, who owned much of the area surrounding the intersection of 164th Avenue and Mill Plain Boulevard; the Abbots; and Napoleon McGillivray, whose father was chief factor of the North Pacific Fur Company, and who may have been the one to build that first Ellsworth sawmill and gristmill in the 1830s.

Fishers and Mill Plain share a long-established history of commerce, politics, and community. They share schools, churches, Granges, romance, and inevitably children and grandchildren. They are, together, Fishers Landing.

# One

# First People and Families

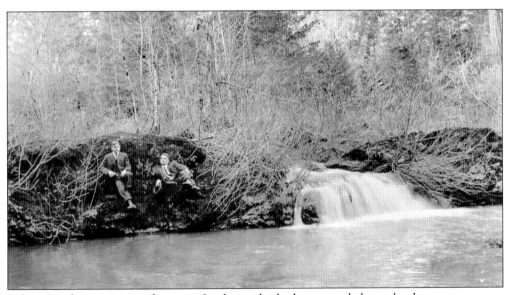

Fishers Landing was a paradise even for those who had not traveled over land or across oceans to reach it. A canoe landing at a spring-fed vale pushed inland into an upper plain and widened into a meadow, a Hudson's Bay village at its center. Men like Roy (left) and Earl Knapp, pictured about 1930, the great-grandsons of statesman Henry M. Knapp and pioneer Rachel Fisher, grew up and flourished here. (Courtesy Two Rivers Heritage Museum.)

9

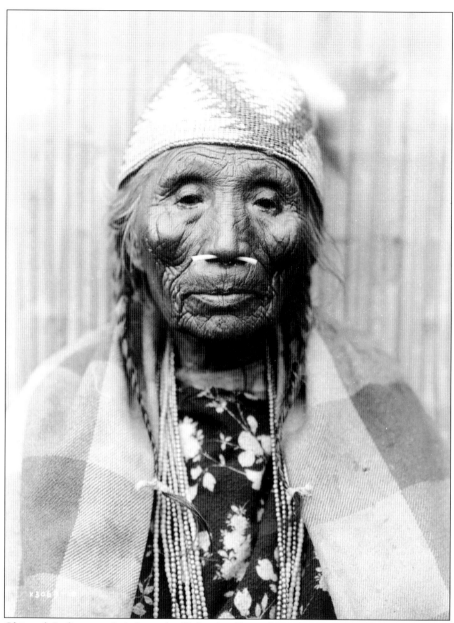

The Chinook Indians traded along the Columbia River from Astoria to Celilo Falls. Their tribes ruled the Columbia River trade and incorporated the Hudson's Bay and Northwest fur traders into their economy. As with other native peoples, interaction with Europeans exposed them to new diseases. At one point, the entire nation was deemed wiped out. There were survivors, of course, and the Chinook trading language, called Jargon, was spoken along the Columbia at least through the 1930s. May Simmons remembers family groups coming through Fishers Landing along the old Cascade track from Fort Vancouver to Celilo, checking river fishing traps as they went. This woman wears a bone through a piercing in her nose, an ornamentation that shows her to be a person of rank. Her hat is an example of renowned Chinook basketry. Native craftswomen used materials including beargrass and cedar and cherry bark for weaving. Waterproof materials included spruce and cedar root. (Photograph by Edward Curtis, 1910; courtesy Library of Congress.)

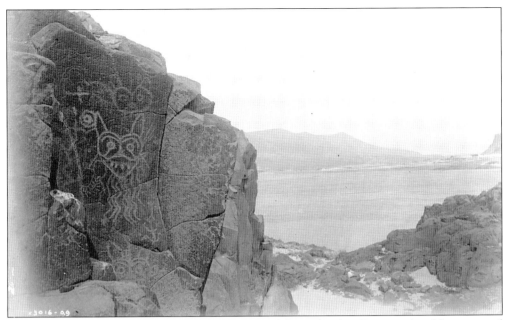

Petroglyphs dot the basalt cliffs and outcroppings of the Columbia Gorge at the old quarry and along the riverbank. Jean Norwood, owner of the Fisher House, tells of a petroglyph that looked to her like a beaver: "[The rock] was hollow in the middle where the animal's tummy would have been, with little paws and little teeth." (Photograph by Edward Curtis; courtesy Library of Congress.)

Native Americans prized the Fishers Landing area, which had particular importance to the women. The Camas potato, or *quawmash*, grew in the marshy springs of Fisher Creek, as did plenty of basketry material. Every year, women from the Columbia River area gathered there to tell stories, swap news, arrange marriages, and harvest the reeds needed to make baskets. (*The Tule Gatherer* by Edward Curtis, 1910; courtesy Library of Congress.)

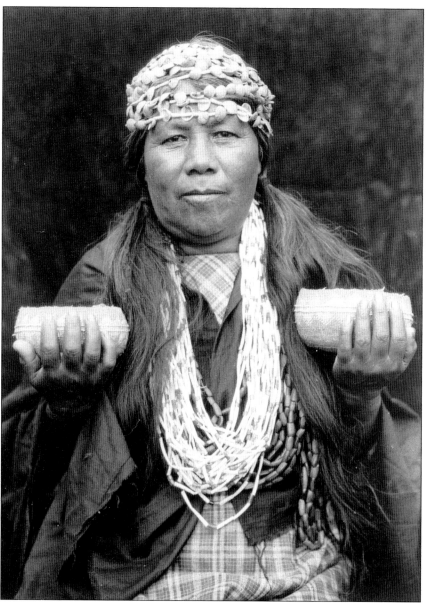

The underground springs that once swelled Fisher Creek now contribute to the rock and water gardens of the Fishers Landing business districts. Before landscaping and the freeway shifted the water's flow, Fisher Creek bubbled up and cut a bank down to the Columbia, meeting up with Fisher Road (164th Avenue) along the way. The creek formed a swimming hole near the river, where the Chinooks, and later the settler's children, spent many warm days cooling off. Nearby was the outcropping, a favorite native fishing spot where Solomon Fisher would later build his landing. Just above the river, where the railroad cut across Fisher Road, was a Native American midden. Fisher historian Jean Norwood tells of a resident who, in digging the foundation for a rock wall, found a Native American fishing net, complete with line and weights. The net, of the type used by Chinook women, was so intricate and beautiful that, out of respect for the artist and her work, the resident put it right back where he found it. (Photograph by Edward Curtis, 1910; courtesy Library of Congress.)

The fur trade was a lucrative enterprise. North American natives from Mexico to Alaska were highly skilled trappers who supplied countless bales of otter, seal, white fox (pictured), and ermine pelts to the traders, who took the furs to sell in China. The political Hudson's Bay Company worked actively to prevent widespread American settlement. New settlements disrupted trade routes and took away land needed by trappers. It is strange to us now, but when Lewis and Clark camped on Government Island in 1806, they were not in the United States. That land belonged to the trapper, "the Company," and the Native Americans. Hudson's Bay dominated the trade, and as that firm was partly owned by the British Crown, the first "coin of the realm" in Oregon Territory was British. Though Oregon Territory coined "beaver money" to use when American coin was scarce, as late as the 1860s, riverboat captain Lewis Love, who owned land at Fishers, was charging ha'penny prices—12.5¢—to ferry foot passengers. (*Inuit Trapper*; courtesy Library of Congress.)

The Hudson's Bay Company established a settlement on Mill Plain and built the first sawmill and gristmill in Washington around 1830 in today's Ellsworth, an area historically associated with Fishers. The Fishers–Mill Plain sawmill, like the Colville River sawmill (pictured), was essentially a shack surrounded by water and forest. Large and productive lumber mills, however, quickly sprang up throughout the territory. (Courtesy Library of Congress.)

In 1844, Britain relinquished the north bank of the Columbia River to the United States, and the land rush was on. Adventurers filled handcarts and wagons—or sailed for months around the horn—to snatch a chance at prosperity. Fortunes were made, and images like this one, printed on a stereograph card for the American parlor room around 1880, fueled the popular imagination. (Photograph by Isaac G. Davidson; courtesy Library of Congress.)

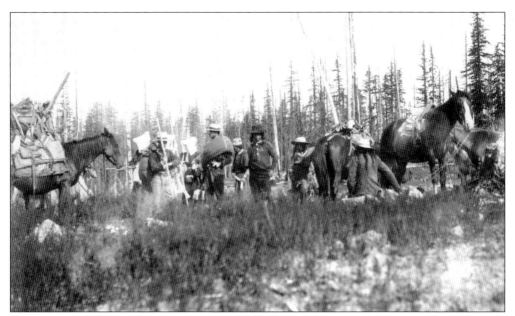

Forests covered the new American territory, cliffs abutted the river, and the cascade rapids made the Columbia nearly impassible. Native Americans offered friendship and expertise as guides and navigators, leading immigrants from Kentucky, Missouri, New York, Sweden (pictured), and Poland; masons; farmers; and printers along the ancient river trails. Their help in times of need saved many pioneers from desperation and starvation. (Photograph by Bertha Robinson Hughey; courtesy Two Rivers Heritage Museum.)

The realities of the settler's life did not quite measure up to the romantic adventure promised in the photographs. The improvements required to "prove" a claim took years. One rule declared that each house have at least one glass window. This was almost laughable. Early pioneers just had to make do, living in lean-to shelters, inside hollow trees, and in rough-hewn shacks that looked like outhouses. (Courtesy Norman Powell.)

In 1850, William Mortimer Simmons and Ann Jemima Fisher Simmons packed up and headed west with Ann's brothers and her sister Rachel. William and Ann would have 12 children, but they lost two before emigrating and two more of cholera while on the Oregon Trail. The party first headed for the California goldfields, but after meeting disappointed prospectors turning back, they changed course and headed for Oregon. (Courtesy Thomas E. Gentry collection.)

Thomas Lincoln "Linc" Simmons (left), seen with Thomas Gentry (center) and Everett Gentry, inherited the Simmons farm and constructed this state-of-the-art milking parlor, complete with concrete floor. Riverview Farms made good money, enough for Linc to retire well and found the town of Ocean Park. He was also a main supplier of dairy products to the 7th Infantry, stationed at the Vancouver barracks. (Courtesy Thomas E. Gentry collection.)

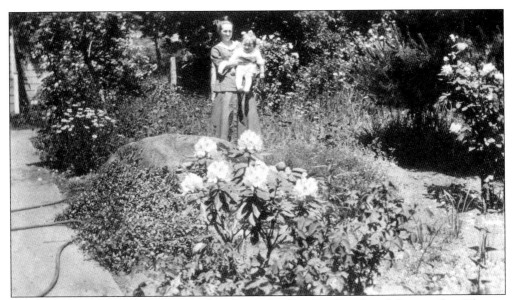

Josephine Alice Lee stands in her prized garden on the Simmons Ranch with her grandson Thomas in 1917. Josephine married Linc Simmons in 1886 and was a skilled midwife. The Simmons home served as a local birthing center, with expectant mothers arriving when their time was due and staying through recovery. Her garden included very potent horseradish. (Courtesy Thomas E. Gentry collection.)

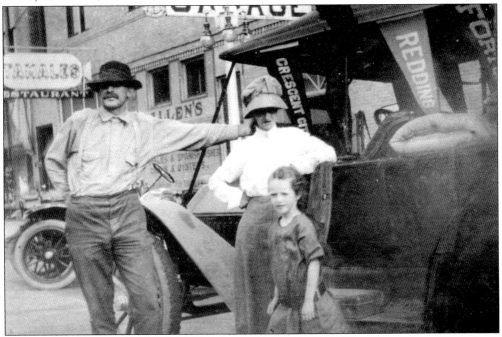

Linc and Josephine—pictured with their youngest child, also named Josephine, about 1910—loved to pack up their touring Mitchell and travel. Lifelong Methodists, they founded the city of Ocean Park as a Methodist retreat. Their grandson Thomas spent many summers there, and the trip, in a Chevrolet "roadster with a box on the back," took 13 hours on gravel roads with at least three flat tires along the way. (Courtesy Thomas E. Gentry collection.)

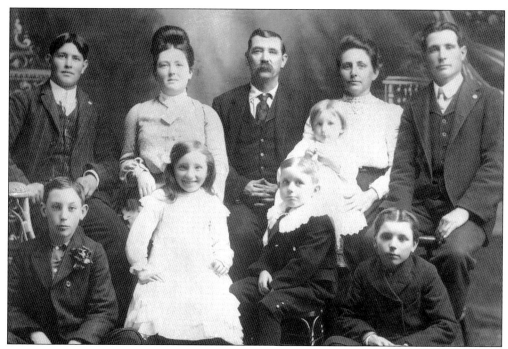

John McCarthy Gentry and his second wife, Margaret, leased farmland from Linc Simmons and settled their family in Fishers. The Gentry family included, from left to right, (first row) Everett Constantine Gentry, Ruby Gentry Gilbreath, Henry Gentry, and Orion Gentry; (second row) infant Gordon Carlyle Gentry; (third row) John Green Gentry, Kathryn Gentry Wallen, John McCarthy Gentry, Margaret William Bowler Gentry, and Lafe Gentry. (Courtesy Thomas E. Gentry collection.)

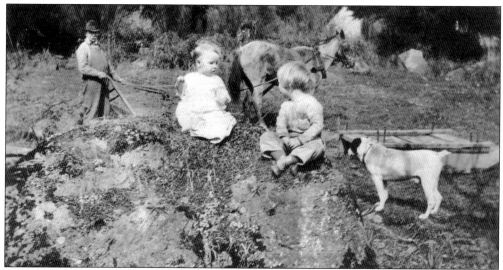

Fishers' soil is some of the best in Clark County. The Missoula floods created a swirling eddy here, depositing rich soil along with Volkswagen-sized rocks. Perched atop one of those rocks are babies Margaret Gentry (left) and Thomas Gentry. Behind them, their grandfather John Gentry works the plow. The mule was named Blue and the dog, Spider. (Courtesy Thomas E. Gentry collection.)

Of Linc and Josephine's children, only Mary Addie "May" Simmons stayed on the family farm. She married Everett Gentry, who acted as farm manager, and raised cows, hogs, chickens and ducks, sweet and field corn, prunes, peaches, cherries, grapes, and potatoes—at 50¢ for a large sack. The land produced plenty; even during the Depression, the family never went hungry. (Photograph by Anderson Studio, c. 1910; courtesy Thomas E. Gentry collection.)

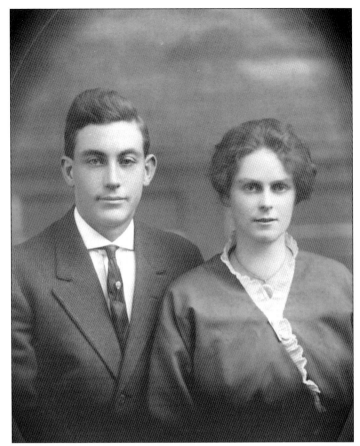

Thomas Gentry was born in the old Remington house next to the Columbia River. Later Everett and May bought and remodeled this house, still standing on Evergreen Highway, which had been used at Fishers Quarry for housing or offices. At one point, many of the old quarry buildings were sold and relocated, with some floated downriver to Vancouver. The fence kept the ranch cows out. (Courtesy Thomas E. Gentry collection.)

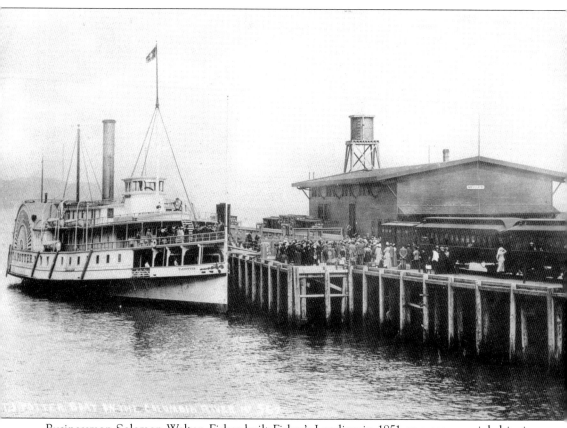

Businessman Solomon Welton Fisher built Fisher's Landing in 1851 as a commercial shipping and refueling dock for steamships on the Columbia River, with a second dock added later. The site included a post office, started as early as 1852 but recognized in 1858, a livery stable, C. H. Danforth's blacksmith shop, mercantile shops, and the Pioneer Building. Near the landing were the Mill Plain Shipping and Trading Company, the Washougal and La Camas Transportation Company, the Columbia Fruit Canning Company, the North Pacific Brewing Company, and Prudence Powell Barnes's store. Other leasers and owners included Frederick Ziegler, George Allen, and merchant and postmaster S. C. Buchanan. The landing shown here is not Fisher's Landing, though there are similarities. Fisher's Landing projected 20 to 30 feet into the river and featured a two-story warehouse. It was wide enough for a wagon and team of horses (and later trucks) to travel down and back and also to accommodate piles of cordwood, milk and butter exports, and sacks of grain and potatoes. The Spokane, Portland, and Seattle Railway Company stopped at Fishers, but did not, as pictured, come out over the water. (Courtesy Two Rivers Heritage Museum.)

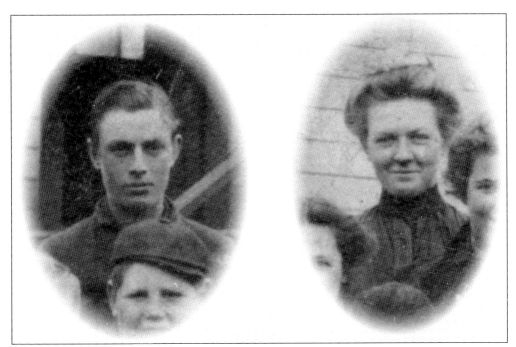

As the children of Job and Lydia Fisher, Solomon "Saul" W. Fisher II (left) and Edna E. Fisher, seen in 1902, inherited the remaining Fishers property in 1905. Tragically, Edna drowned that same year at just 19. Saul Fisher, 20 years old, inherited his uncle and father's estate, estimated to be worth $7,000 in 1903. Saul maintained the landing, school, and church and ran a dairy farm on Fishers Hill. (Courtesy Norman Powell.)

The original Fisher house was demolished by the Northbank Railroad in 1907. Only a few Queen Anne cherry trees remain to mark the spot. Saul Fisher contracted Ransom Powell to build another residence, the historic Fishers House on Evergreen Highway. Luxuries included piped hot water, even to a sink on the front porch, and gas lighting. Dances were held in the south-side barn. (Photograph by R. Fairhurst, 2007.)

Henry Monroe Knapp, a four-term territorial legislator, married Rachel Fisher in 1853 and settled in the Grass Valley area. A businessman and gentleman, Knapp served as Clark County auditor in 1852 and assessor in 1860. He founded the Mill Plain and LaCamas Granges and was a deputy grand master of the Oregon Grange. Knapp was present at the signing of the Washington State Constitution. (Courtesy Two Rivers Heritage Museum.)

The beautiful Knapp estate, pictured around 1920, produced abundantly; the dairy cows gave 100 pounds of butter each week. Henry and Rachel Fisher Knapp had six children, but three died young. Rachel passed away in 1863, and Henry married Anne Huffman, his housekeeper, in 1865. After Henry died, Anne wed Knapp farm worker George Briggs, and together they developed a good part of Prune Hill. (Courtesy Two Rivers Heritage Museum.)

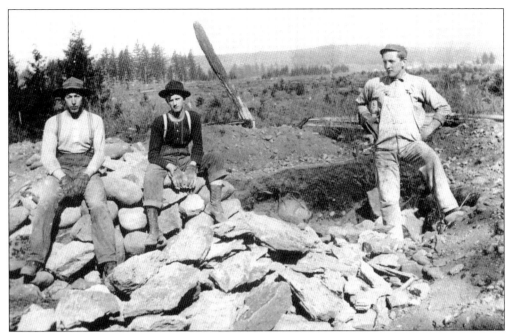

The La Camas Colony Company incorporated in 1883, and as the city of Camas grew, the Knapps became important members of that community. Henry M. Knapp's grandson Claude Knapp (left), born in 1889, built a number of Camas homes and buildings, including the chamber of commerce and today's Liberty Theater, originally called the Granada Theater. (Courtesy Two Rivers Heritage Museum.)

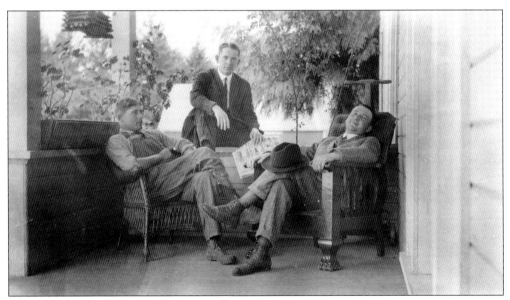

The Knapp home—surrounded by fruit orchards, dairy meadows, and fields of timothy hay—featured a ballroom on the second floor. Anna Huffman Knapp cooked meats, pies, and cakes for days before a dance. The events lasted well into the morning, and Knapp grandsons Roy (left) and Earl (center), shown with their friend Hoxie about 1920, were known to head out afterward in search of more dancing. (Courtesy Two Rivers Heritage Museum.)

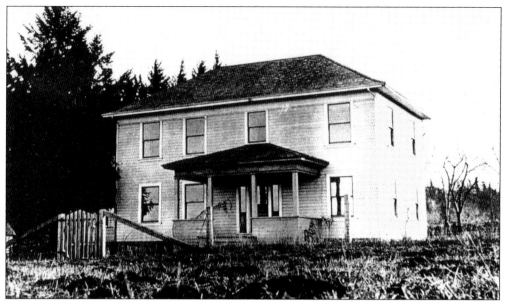

Fire destroyed the original Knapp farmhouse in the 1920s, and no trace of the home, barns, or orchards remains. Roy Knapp built this home in the Brady Road area and owned the Knapp Brothers Dairy. Well known in Vancouver and Portland, he was one of the investors, along with Henry Pittock, in the construction of Portland's first five-star hotel. (Courtesy Two Rivers Heritage Museum.)

As the automobile revolutionized travel, the truck revolutionized freight. Before then, all freight was hauled by horse and wagon and then shipped out by railroad or steamship. The costs for storage at the wharf and for shipping were steep. Some, like John Lovelace, solved the problem by building their own dockside warehouses. The advent of the truck soon freed the farmer of steamship and rail charges. (Courtesy Two Rivers Heritage Museum.)

Hugh Knapp was a member of the undefeated Camas High School football team in 1937 and graduated in 1939. A great-grandson of Henry M. Knapp, Hugh became a distinguished Camas lawyer. He served as the attorney for the Port of Camas–Washougal for over 30 years and was admitted to practice before the U.S. Supreme Court in 1979. (Courtesy Two Rivers Heritage Museum.)

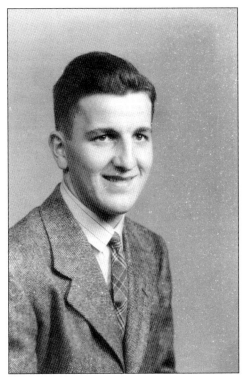

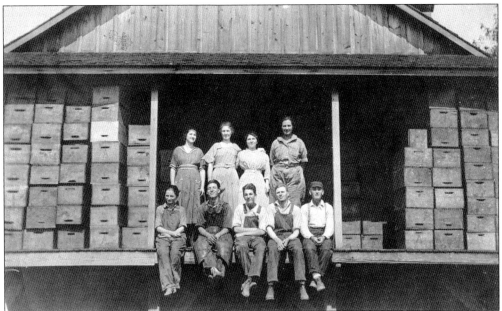

The Knapps helped develop Prune Hill, which had become thick with prune orchards by 1900. Prunes cropped up everywhere, however, not just on Prune Hill. And during the season, all hands worked to pick and pack fruit. Those working this dryer on Southeast Fifteenth Street around 1920 are as follows, from left to right: (first row) two unidentified people, Ernest Sampson, John Duback, and unidentified; (second row) Mildred Bybee, Sarah Bybee, Lillie Bungie, and unidentified. Ernest and Lillie were later married. (Courtesy Pat Forgey.)

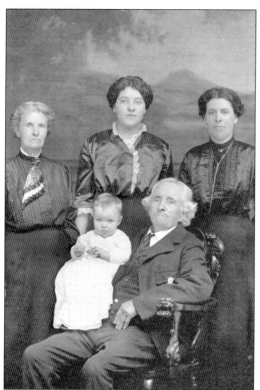

Widower Archibald Tuttle (seated) traveled west to Mill Plain in 1900. His children married the Dubacks, Timmonses, Forgeys, Carpenters, and Powells of the Fishers Landing area. Tuttle, who lived into his 90s, poses about 1913 for a five-generation portrait with his daughter Mary E. Timmons (left), great-granddaughter Anna Hood (center), granddaughter Malinda Powell (right), and great-great-granddaughter Margaret Hood. (Photograph by Anderson Studio; courtesy Norman Powell.)

Government and Lady Island families were intimately connected with Fishers Landing. The Goodwins, Fletchers, and Durgins were early settlers to the islands, and Saul Fisher's house overlooked Lewis and Clark's 1806 island campsite (pictured). Norman Powell lived on Government Island as a boy. He remembers his mother warning, "Be careful what you say about folks on the plain—'cause you're related to most of them." (Photograph by R. Fairhurst, 2007.)

Civil War veteran John Whittingham Timmons (left) survived the notorious Andersonville prison camp in Georgia. He walked home after his release and, while in Nebraska, saw a horse and rider galloping bareback down the street. The rider was a woman, and Timmons swore right then that he would marry her. He and Mary Elizabeth Tuttle were indeed wed in 1868. They moved west with her family in 1900. (Courtesy Norman Powell.)

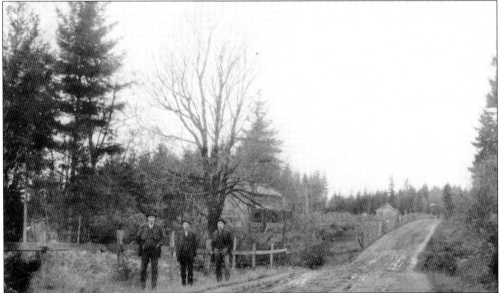

Dave Shipley (left), his son Bill Shipley (center), and John Timmons stand in front of the Timmons home on the old Evergreen Highway around 1900. Saul Fisher built his house nearby in 1907. The Timmonses made a home at Fishers, but the Shipleys, who came out by rail to evaluate, turned right around and headed back. (Courtesy Norman Powell.)

Brothers Gideon and Thomas Summers Gillihan settled in Fishers Landing to farm and were well known in the community. Gideon, a Civil War veteran, became justice of the peace for the Preston Precinct, which included Fishers. Thomas served as chaplain of the Washington State Grange and as founder and lee of the Preston Grange. Seen here is Thomas's son George L. Gillihan. (Courtesy Annetta Anderson.)

In the days of parlor rooms and calling cards, William Wagenblast, whose aunt Louisa Wagenblast married Vancouver brewer Henry Weinhard, was a parlor room guest at the Blair house on Mill Plain. In 1880, William married Mary Jane Gillihan, pictured here with her daughter Joda. Joda attended the Mill Plain School, where her grandfather Thomas Summers Gillihan served as director of the school board. (Courtesy Annetta Anderson.)

Tragically, William Wagenblast, shown about 1880, never really knew his daughter Joda. One day while in Portland, William was shanghaied and forced to labor on one of the many ships of the Pacific. When finally freed, he arrived home a haggard and broken man, unable to resume his former life. His wife, Mary Jane, had presumed William dead and married James Baker in 1887. (Courtesy Annetta Anderson.)

Threshing machines, like this one on Mill Plain, were good business. In 1881, Jacob Wagenblast, whose farm became part of Fishers Quarry, partnered with one of his Proebstel brothers-in-law, and their crew threshed 1,315 bushels of oats in 10 hours using a Canton Pitts 24-inch cylinder machine. Workers also wire-cut 30 acres of wheat in 18 hours with a Walter A. Wood machine and six horses. (Courtesy Norman Powell.)

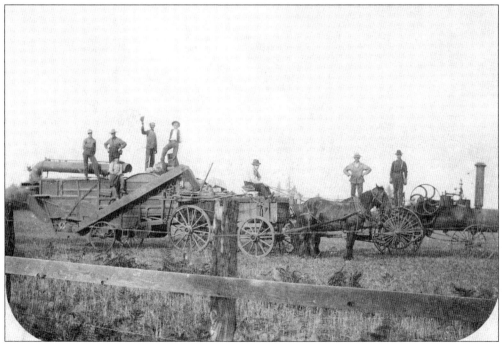

Kentuckian James Bybee—pictured with his third wife, Ellen Day, in 1900—came west in 1850. He headed first to the goldfields, but after discovering the price charged for produce in California, he moved north to farm. He settled first on Sauvies Island and then ran a dairy on the Willamette. In 1868, Bybee moved to Clark County, taking up 320 forested acres on today's McGillivray Boulevard. (Photograph by Hofsteater; courtesy Pat Forgey.)

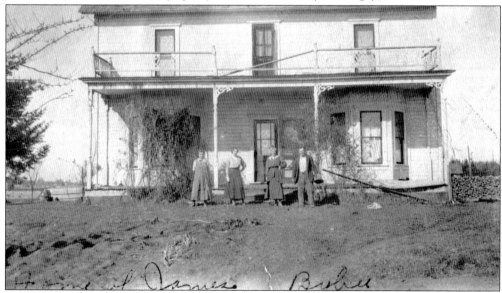

James Bybee married his first wife, Eudora Sturgis, in 1855. The couple built this home in Fishers Landing, which was reputedly identical to Bybee's first home on Sauvies Island. At its height, the Bybee farm totaled almost 600 acres, most of which were cleared and plowed, and included eight acres of cultivated fruit orchards. In 1868, the family's closest neighbor, through thick forest, was Jacob Duback. (Courtesy Pat Forgey.)

James and Eudora Sturgis Bybee had nine children, including, from left to right, Clara, Lillie, Adeline "Addie," and Eudora "Dude." Eudora Sturgis died in 1894. James Bybee's first and third marriages were happy, but his second ended in divorce. As can happen today, the divorce proved acrimonious. Records consist of scandalous 19th-century accusations such as "damned fool" and "damned liar." (Photograph by Hayes and Hayes; courtesy Pat Forgey.)

The Bybee family was close knit even as it grew and branched out into the community. Gathered in 1920 are the following, from left to right: (first row) Gay M. Bybee's nephew "Little Gay," Nora, Lea, and Addie; (second row) May, Leland, Charles "Doc," and Gay M. Bybee. Eudora "Dude" Bybee sits in the center. (Courtesy Pat Forgey.)

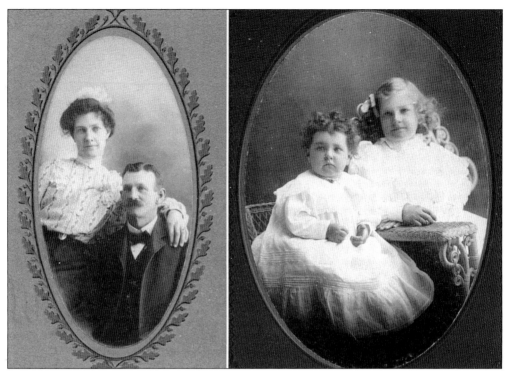

Gay Bybee wed Sarah "Sadie" Rees, pictured at left in 1894, just before his mother died, and at her request. The couple had two girls, Mildred (left) and Lola, shown at right in 1894. Sadie's father, a Baptist minister in The Dalles, wrote often. In a letter dated 1886, he penned, "Darling Sadie, Be a good Christian girl, and meet your dear mother in heaven." (Photographs by Thompson; courtesy Pat Forgey.)

Historic Fishers Landing was marshy, muddy, rainy, "can do" country, where even the wealthy made do. A gentleman who built a school might also be the janitor and perform all the repairs himself. Yet the town's families still enjoyed trendy, gentrified pursuits. On this postcard, Lola Bybee (left), Marjorie Blair (center), and Mildred Bybee hold croquet mallets while standing in the mud in their Sunday best. (Courtesy Pat Forgey.)

Mildred Bybee (left), pictured in 1919 with Olive Blair (center) and Shellie Slyter, married Jack Frost and became active in Fishers Grange. Mildred's daughter would recall the rowdy Saturday night Grange dances, when her mother bid her to follow two specific rules: 1.) Do not show favoritism; dance with whomever asks you, unless they have been drinking; 2.) Never go outside during intermission. (Courtesy Pat Forgey.)

Laurence Forgey wed Addie Bybee in June 1906. The well-respected Forgeys raised seven children in the log house across from today's Union High School. "Forgey's Hump," west of the Forgeys' place on Southeast First and 172nd, was a favorite with teenagers. Bob Hitchcock Jr. remembers riding with Phil Friberg in his 1959 Chevy: "It was great. If you could get all four wheels off the ground, that's what you wanted. (Courtesy Pat Forgey.)

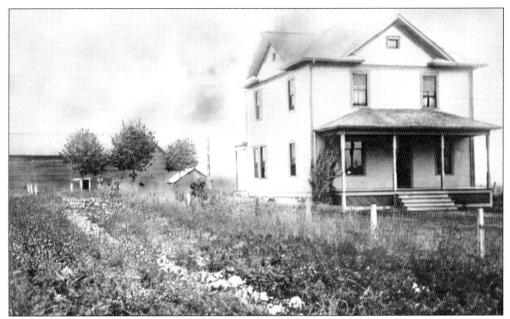

Like many families headed west, the Blairs arrived en masse with brothers, cousins, and their families all traveling together. Frame Blair came with his brothers Pinkney and Jasper and his cousin Rufus in 1873. Frame's brother Hannibal and Rufus's brother Mat arrived in 1875, followed by brothers William and Robert in 1884. Frame settled in Fern Prairie, then Vancouver, then purchased a 115-acre farm on Mill Plain (pictured). (Courtesy Patsy Ferguson Sleutel collection.)

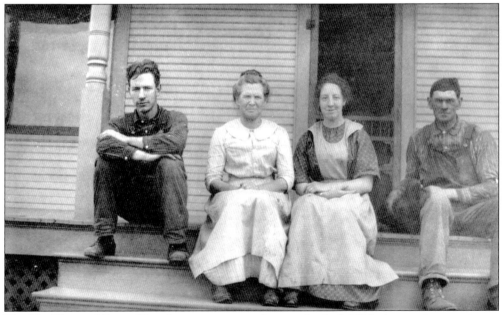

The Mat Blair and Frame Blair farms encompassed most of today's 164th Avenue intersection at Mill Plain Boulevard. Frame wed Mary E. Nerton Calder (second from left) in 1882—a second marriage for both. Mary and Frame had six children, including Sidney (left) and Lulu (third from left). William Calder (far right) was Mary's son by her first husband, Edward Calder. (Courtesy Patsy Ferguson Sleutel collection.)

Born in 1886, Sadie Blair (pictured) came of age on the Mill Plain farm, spending her life on the portion she inherited. Today Sadie would be an avid scrapbooker, for as a young woman she saved advertisements, calling cards, and penny postcards. Before her marriage to Jay Ferguson in 1912, Sadie spent summers with her stepsister Lucy Blair Hathaway, the wife of Alfred O. Hathaway, in Washougal. (Courtesy Patsy Ferguson Sleutel collection.)

The easy friendship displayed around 1920 by Blair sisters Nora Carpenter (left), Lottie Carpenter (center), and Sadie Ferguson typifies what was once called "life on the plain." This farmland would become part of the gravel mine between Mill Plain Boulevard and First Street in the 1990s. In the 1950s, where Home Depot is today, Frank Siegels raised acres of gladiolus flowers at $1.25 per fresh-cut dozen. (Courtesy Patsy Ferguson Sleutel collection.)

Blair grandsons Royal "Roy" Carpenter and Clyde Verle "Fat" Ferguson sport the trendy boys' *Little Lord Fauntleroy* hairstyle and clothing of the early 1900s. The cousins grew up together and attended Union High School, where Royal lettered in football. Verle served in the coast guard during World War II and was chairman of the school board in the 1960s. (Courtesy Patsy Ferguson Sleutel collection.)

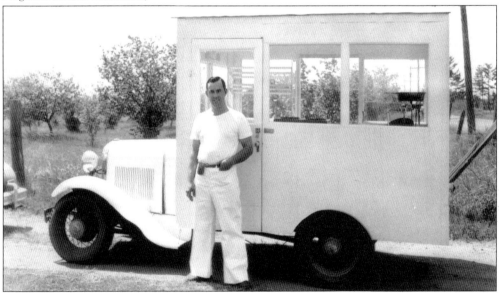

Before there was the ice-cream man, there was Verle Ferguson, shown here about 1950. A lifelong papermaker, Verle also drove this snack truck, which included a cast-iron skillet and gas burner. He sold soda, hot dogs, and fresh popcorn. On Hitchcock's Corner, near First Street and 192nd Avenue, was Verle's competition. There Buslach's Store sold groceries and grilled hamburgers, and on Halloween, Buslach's gave free ice-cream cones to local kids. (Courtesy Patsy Ferguson Sleutel collection.)

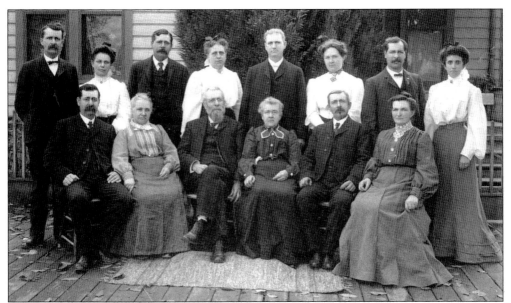

The Hitchcock brothers traveled west in the 1870s. William "Henry" Hitchcock settled on 10 acres in Mill Plain in 1890. James and Emily Hunt Hitchcock pose for a photograph with their sons and daughters-in-law. Pictured from left to right are the following: (first row) Frank and his wife, Ola; James and Emily; and Henry and his wife, Almina; (second row) George and his wife, Emma; Charles and his wife, Ella; Edwin and his wife, Lucy; and Alton and his wife, Kitty. (Courtesy Bob Hitchcock.)

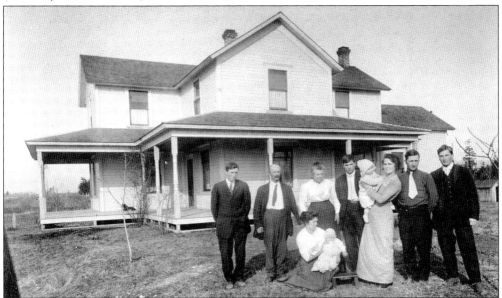

The Atkins family owned a large farm from the southeast corner of 164th and McGillivray back to 192nd Avenue. The first farmhouse burned. This home, constructed about 1900, had no bathrooms or plumbing. Seen here from left to right are Clyde Atkins, James Atkins, Elizabeth Atkins, Samuel "Babe" Atkins, Grace Atkins Hitchcock, baby Bob Hitchcock, Roland "Rolly" Hitchcock, and Gordon Atkins. In the front, Ruth Kramer Atkins holds baby Helen Atkins. (Courtesy Bob Hitchcock.)

Fishers Landing was once a landscape of postage-stamp farms and huge hay barns. Swedish immigrants Oscar and Hilma Arvidson purchased this farm, which stretched between Fishers Quarry and today's Hewlett Packard campus on Southeast Thirty-fourth Street. The farm was previously owned by horse trainers and featured stables and a training track. Another family, just west of the Arvidson place, raised and trained fine carriage horses. (Courtesy Dory Brooking.)

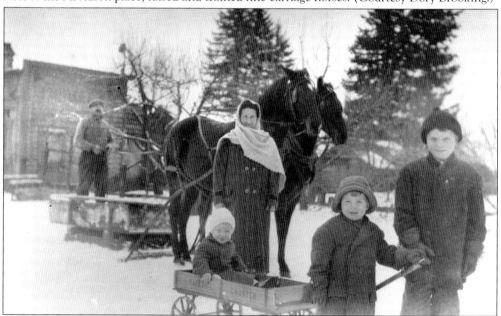

Oscar and Hilma walk the Arvidson farm in 1906 with their boys Albert (left), Jack (center), and Carl. Their son Fred was born later, in 1910. Owning horses, threshers, and bailers, Oscar worked the harvest for local farmers. Fred and Ray Arvidson acquired the family business, supplying alfalfa to the Portland racetrack. Carl worked for Crown Zellerbach, while Albert worked aboard a steamship on the Columbia. (Courtesy Dory Brooking.)

German-born Jacob and Dorothy Saurer Duback settled on 500 acres north of Fisher Hill extending both east and west of 164th Avenue. Nearby their beautiful estate home, they planted, among other things, plenty of German prune trees. The barn, worth $2,500, was one of the best in the county. Duback's grain crop totaled perhaps 4,000 bushels in 1880. Lloyd Duback is shown here in 1918. (Courtesy Pat Forgey.)

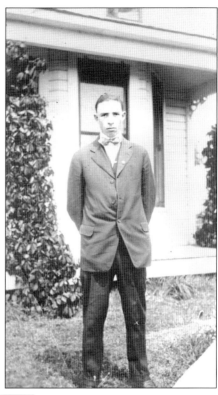

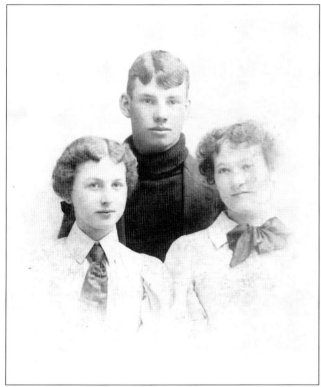

Jacob Duback's wealth was evident when tragedy struck. In 1880, a fire destroyed the barns, granary, and machinery and caused more than $8,000 in damage—a fortune at the time. Life, however, remained good. The 12 Duback children married into local families, and Jacob Jr. became an optometrist. Robert Edwin "Ed" Duback, who wed Mary Elizabeth Young, is pictured with Eunice Bybee Scott and Addie Bybee about 1895. (Photograph by Hofsteater; courtesy Pat Forgey.)

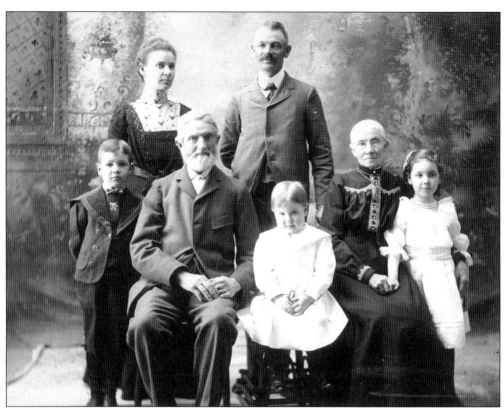

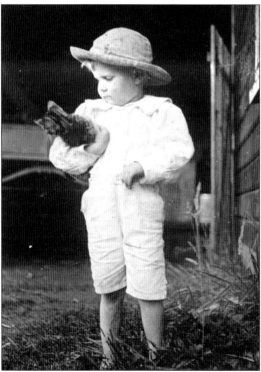

Carl and Betah English (standing) migrated west from Michigan in 1902 with their three young children—Roy (left), Ferris (center), and Zella, seen here with their grandparents Jude and Perses English around 1901. Carl purchased 240 acres at today's 172nd and Southeast First Streets for $17.50 an acre. He brought water and electricity to the farm using a windmill and started the Mill Plain Telephone Company. (Courtesy Gene English.)

Ferris English, shown about 1906, graduated from Union High School, served in the marines during World War I, and married Vida Hennings in 1930. After inheriting the English farm, he built one of the most productive dairy farms in Clark County. Ferris and Vida were dedicated Grangers, with Vida holding state office. Vida graduated from Camas High School and became a well-respected Camas schoolteacher. (Photograph by Carl English; courtesy Gene English.)

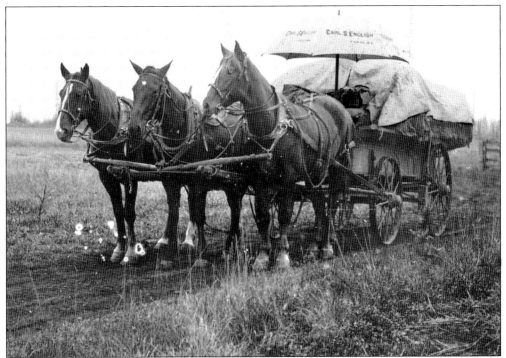

The ice storm of 1916 destroyed the English prune orchard, leaving Carl with the one thing he already had plenty of: firewood. Potatoes proved the most lucrative crop, and Carl, with loaded wagon pictured, became a major supplier to Fort Vancouver. In earlier days, Camas addresses extended farther west, making the Carl English farm part of Camas. (Photograph by Carl English; courtesy Gene English.)

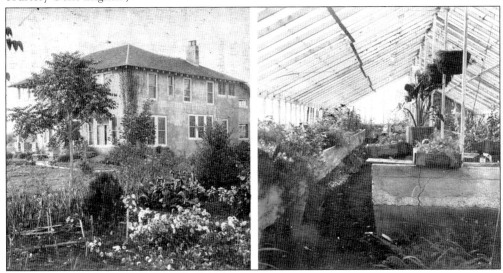

Carl English built a large brick home in 1916 (left), and he and his wife, Betah, raised eight children there. His son Carl S. English Jr. became a renowned botanist. Carl Jr. cultivated the gardens and constructed a greenhouse (right), complete with an underground wood and duct heating system. The historic Carl English home stands today as the English Winery. (Photograph by Carl English; courtesy Gene English.)

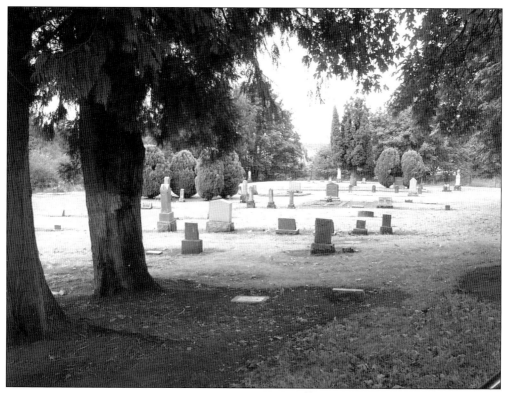

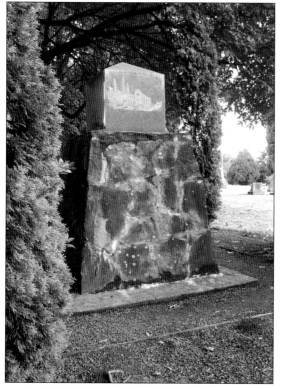

William Simmons donated land for a cemetery in 1852, thereby founding the oldest public cemetery in Washington. Located at the base of 164th, the cemetery's original graves may pre-date the 1850s, and the first wooden grave makers, perhaps identifying Hudson's Bay men or early pioneers, have long eroded away. Monuments to mothers lost and children drowned chronicle the stories and tragedies of Fishers Landing's first families. (Photograph by R. Fairhurst, 2007.)

Norman Powell served as Fishers Cemetery caretaker for 30 years. He relates that his aunt Clara Powell Kreeger "lost sleep" thinking about those buried in the unmarked graves. At her urgings, Powell erected this memorial for the adventurers, laborers, and pioneers buried—with and without markers—at Fishers. The monument, erected with community donations and support, features a marble top that Powell purchased himself. (Photograph by R. Fairhurst, 2007.)

# *Two*

# LIFE AT FISHERS AND ON THE PLAIN

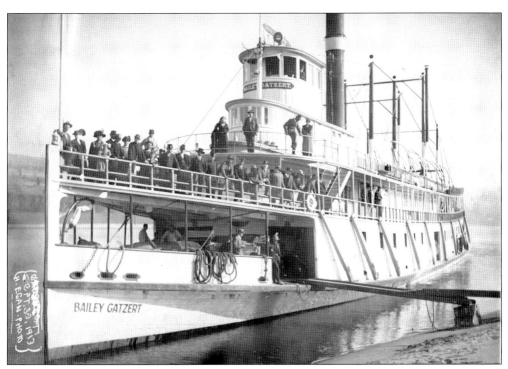

From the mid-1800s to the early 1900s, riverboats ruled the river. The *Bailey Gatzert* (pictured in 1913), with her distinctive, melodic whistle, was queen of the Columbia River steamships. Countless photographs and postcards romanticize her sojourns along the river. Solomon Fisher's landing, with two docks and high- and low-water ramps, rivaled Vancouver for importance as a shipping and refueling point. (Photograph by H. Egan; courtesy Two Rivers Heritage Museum.)

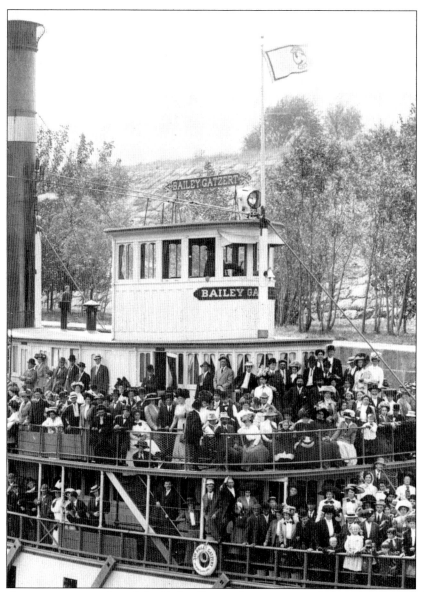

As these happy passengers aboard the *Bailey Gatzert* demonstrate, a day's ride or moonlight tour on a beautiful Columbia River steamboat was a festive occasion. The *Dalles City, Jesse Harkins, Undine, Ione,* and *Joseph Teal* were all regulars to Fisher's Landing, as were Capt. Lewis Love's *Calliope* and *Traveler.* Steamboats were the combination tour buses and tractor-trailer trucks of the Columbia River freeway. And sometimes they were the ambulances too. In 1882, as William Laver brought his scow from Government Island into Fisher's Landing, he collided with the incoming *Traveler.* Laver's lower body was crushed in the accident. He was quickly wrapped up and carried to the *Traveler,* and the captain transported him to St. Joseph's Hospital. In 1877, Captain Love carried the children of the Mill Plain Sunday School, free of charge, from Fisher's Landing to Parkersville for a picnic. And when Henry Pittock's La Camas Colony Company started work on the future town of Camas, Love provided excursions for the curious, transporting those from Portland who wanted to see the amazing goings-on for themselves. (Courtesy Two Rivers Heritage Museum.)

Locals, such as this *c.* 1912 gentleman, knew all the best fishing spots. Clara Powell Kreeger, who owned a general store near Fisher's Landing, recorded that from road level, one could see a huge warehouse built on pilings at "the dock." Later trucks replaced horse-drawn wagons and hauled freight along a side ramp, their load perhaps consisting of huge, four-to-five-foot wheels of cheese destined for Blair's Store. (Courtesy Thomas E. Gentry collection.)

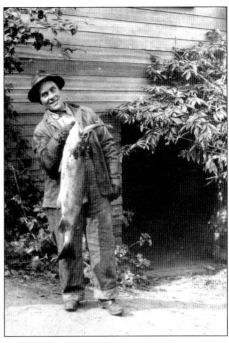

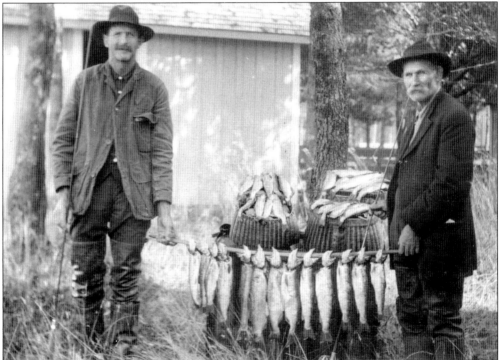

Cut lumber was expensive, but pioneer William M. Simmons refused to build a log home. Instead, he towed cut lumber from the Hudson's Bay sawmill at Fishers (Ellsworth) and built a two-story house with a long front veranda on a prominent point on the Columbia River. His youngest son, Linc (left), seen with his friend John Rausch in 1910, made many improvements to the farm, including the installation of a large trout pond. (Courtesy Thomas E. Gentry collection.)

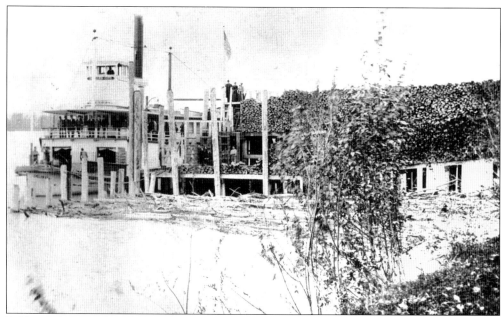

Public and private boat landings dotted the river. On smaller landings, passengers needed only to wave a white flag and passing riverboats would pick them up. The *Dalles City* stopped twice a day at Remington Landing, shown here in 1892. As the crew loaded cordwood, Captain Short rushed over to the Simmons house for coffee and pie—and perhaps a kiss—from his sweetheart, who worked there. (Courtesy Thomas E. Gentry collection.)

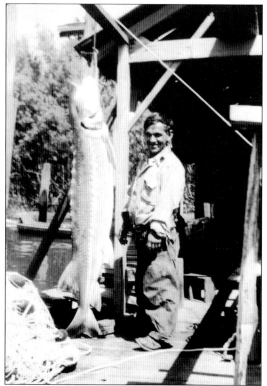

Native American "Shorty" Stanger lived just south of the Simmons homestead. Here, at Remington's Landing about 1910, Shorty poses next to a fresh-caught sturgeon to make it appear larger. Alex Remington built his landing on land he rented from Linc Simmons. A farmer and businessman, Remington served as justice of the peace and secretary of the Preston Republican Club and advocated growing King Phillip sweet corn and Burbank potatoes. (Courtesy Thomas E. Gentry collection.)

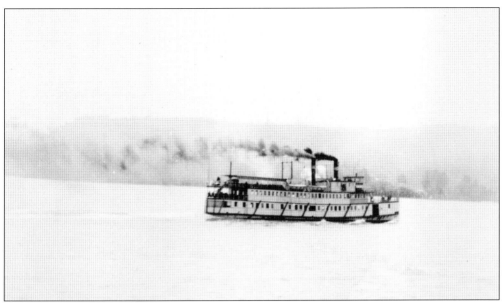

Self-made millionaire Lewis Love reportedly subsisted on flour and molasses during the winter of 1849, his first in the Oregon Territory. In 1862, he built a successful sawmill and gristmill at Fishers, transporting grain on his first boat, the scow *Ida Ann*. The next year, he and his partners built the *Iris*, the *Kiyus*, and the *E. D. Baker*, competing on the river with the giant Oregon Steam Navigation Company. (Courtesy Two Rivers Heritage Museum.)

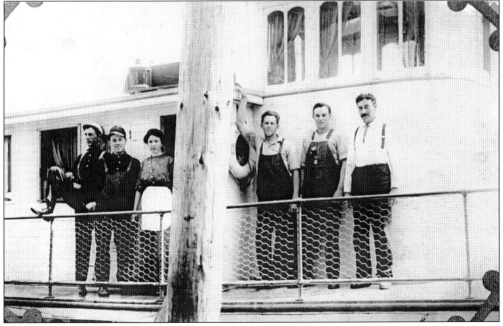

The *Jesse Harkins*, pictured with crew members such as Henry Wren (second from left), made regular stops at Fisher's Landing. Cordwood, which lined the docks and up Fisher Road (164th) as far as today's McGillivray, sold for between 85¢ and $2 a cord. Cut into four-foot lengths, the wood was carried one on each shoulder and loaded by the crew from the gangplank. (Courtesy Two Rivers Heritage Museum.)

Small-town doctor Emil "Brook" Brooking (right) worked 43 years in Camas, raised eight children, and served 12 years on the Camas School Board. He and his wife, Dory, purchased reclaimed quarry land on the Columbia River in the 1950s as a family camping spot. The Brookings' love for that land led them to partner with the Columbia Land Trust, therefore preserving it for future generations. (Courtesy Dory Brooking.)

The *Jessie Harkins* sailed regularly from Fisher's Landing. The fare to Vancouver was 25¢, and children rode for free. Surprisingly, though many enjoyed river recreation, few people along the river could swim. Many families lost one or more members to drowning. On July 23, 1905, three girls—May and Lillie Ziegler and Edna Fisher—waded out from Government Island, slipped on the clay riverbed, and drowned. (Courtesy Two Rivers Heritage Museum.)

Government Island is situated in Oregon, but historically Solomon Fisher owned much of it, renting to local Fishers families like the Lavers, Hoods, and Powells. William Barlett rented a small farm and operated a landing on the island while also working as dockmaster for Solomon at Fisher's Landing. Ruby Gentry Gilbreath (right), shown with May Simmons Gentry around 1910, taught school on Government Island and commuted by rowboat. (Courtesy Thomas E. Gentry collection.)

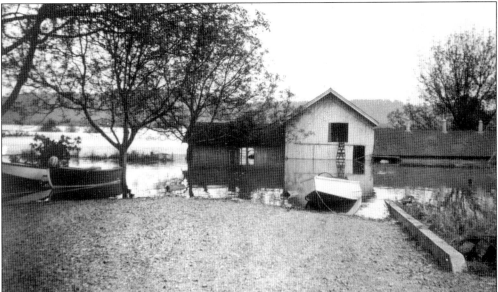

Flooding along the Columbia usually came in a constant, rising swell, and the great flood of 1894 was no exception. As the river rose, families hurriedly moved cattle and cordwood to higher ground. Over time, the Lavers on Government Island lost half their farm to the river. Three times they moved the family home away from the water's edge to prevent it from disappearing into the river. This photograph depicts the Vanport flood of 1948. (Courtesy Two Rivers Heritage Museum.)

This *c.* 1910 postcard from Sadie Blair's collection illustrates just how much the folks of Fishers Landing liked to dance. Dances were held in the Grange hall and in people's barns, such as the old Fisher barn, which was later converted into a home. Grange dances had a reputation for being rough. "I wasn't allowed to go," Jeanette Arvidson remembers. "Too much fighting." (Courtesy Patsy Ferguson Sleutel collection.)

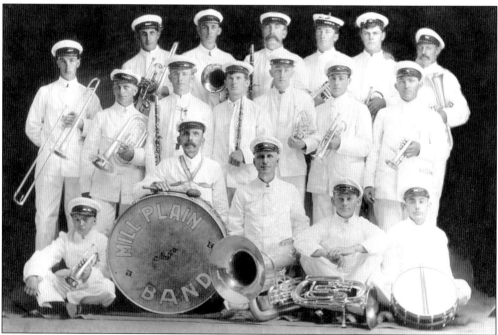

Everett Gentry (first row, far right) played the snare drum in the Mill Plain Band in 1909. The 17-member brass band performed in Fishers Landing and in Vancouver. Everett met May Simmons while playing at a dance in Fishers. Everett also studied the violin and painted in oils. He sold his oils at Gentrys, advertising them for "Christmas and birthday gifts." (Courtesy Thomas E. Gentry collection.)

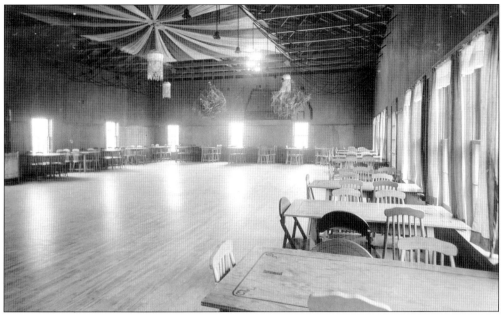

In 1934, Everett Gentry built the Ten Mile Dance Hall with maple floors and then leased it to "Slim" and Edna Lindstrom. This view was taken from the stage where the five-member family orchestra called The Fields played. The dance hall was not a place to meet singles. "You better bring your own girl," Thomas Gentry remembers. Any funny business and a "monster bouncer" would throw people out. (Courtesy Thomas E. Gentry collection.)

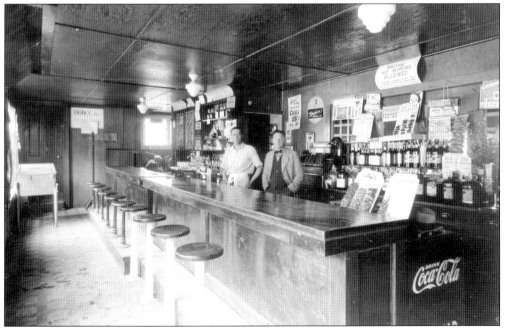

Built adjacent to the dance hall, the Ten Mile Tavern sold wine and served beer by the pitcher. On weekends, the hall was packed by 9:00. Unfortunately, parking was such a nuisance that the tavern shut down. The building, still standing on Evergreen Highway, went to heavy equipment repair, and the beautiful floors were ripped out. (Courtesy Thomas E. Gentry collection.)

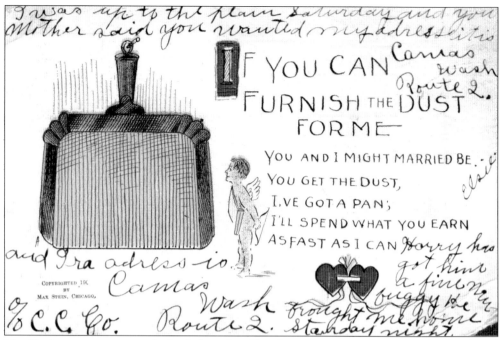

Usually the message goes on the back, but when Elsie from Camas sent this postcard to her friend Sadie Blair in 1908, she wrote on the front, "I was up on the plain Saturday night. . . . Harry has got him a fine new buggy, he brought me home Saturday night." Perhaps Elsie wanted to draw attention to the lines "You and I might married be." (Postcard by Max Stein; courtesy Patsy Ferguson Sleutel collection.)

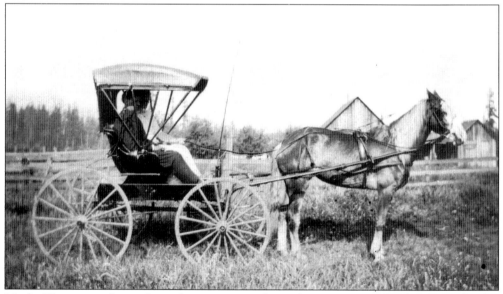

Maybe Elsie was right; perhaps there *was* something about a man with a buggy, as the few photographs of Sadie Blair and her beau, Jay Ferguson, show them snuggly tucked into a sweet little horse-drawn buggy. Jay must have swept Sadie off her feet, because the bulk of her postcard collection is dated prior to her meeting the dashing young man, whom she married in 1912. (Courtesy Patsy Ferguson Sleutel collection.)

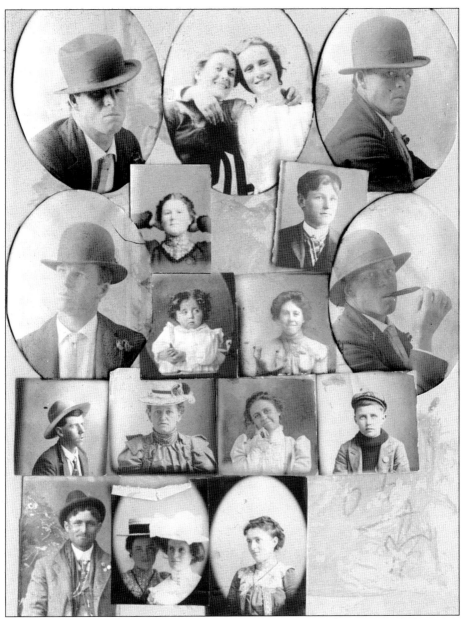

Joda Wagenblast created this collage of her Mill Plain friends around 1895. Had she known Sadie Blair, they might have been fast friends, as life at Fishers Landing comes alive from snippets of Sadie's postcard collection. In 1914, Lou Blair wrote, "Dear Sister, Mama and I are busy this morning, Will Groth is here binding the grain guess he will finish to-day. Hoyt and wife are here, on the plain, they came Tue eve but are visiting around other places as Lela took sick July 22, she has a boy they are fine. The buggy is in the shop or we would bring you some eggs." In 1909, her sister Dola penned, "Dear Sadie, . . . we went after hazelnuts yesterday and we got about a half a sack apiece. The baby crawls everywhere now and climbs up by everything." Another sister noted, "I am still working in the prunes. I expect you are glad you are not working in the prunes." Sadie received this message in 1907: "We are nearly drowned out down here, how are you?" Yet another friend writes to say that Muffet had two kittens. (Courtesy Annetta Anderson.)

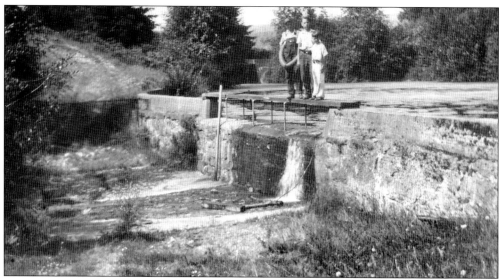

Dams, pipes, and a Pelton wheel generated electricity for Riverview Farm (pictured). Thomas Gentry remembers "lights everywhere"—that is, except when pitch black descended because a sturgeon had plugged the generator. Young Thomas held the lantern as his dad made repairs. When the fish came loose, freezing water exploded from the pipe. Frightened, Thomas took the lantern and ran, leaving his dad to freeze, soaking wet, in darkness. (Courtesy Thomas E. Gentry collection.)

Fishers Landing farmers such as Linc Simmons, see the T. L. Simmons ordering invoice (above), improved their farms, increased their holdings, and started businesses. In June 1909, May Simmons ran the Orchards Shipping and Commission House, ledger excerpt pictured (below), later called Simmons and Schooner, which handled everything from ladies' opera gaiters to orders of 6,000 dozen eggs and 10,000 pounds of butter. Clerks Gossett and Attridge earned $2.875 a month. (Courtesy Thomas E. Gentry collection.)

54

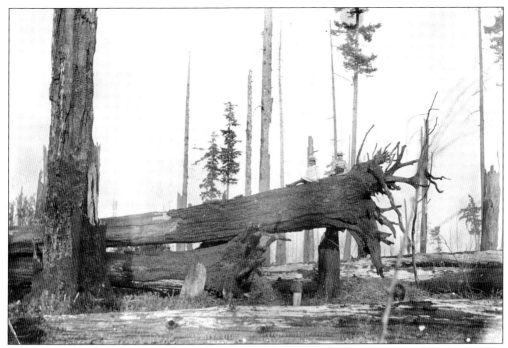

The great gale of 1880 laid whole forests to the ground and left roads impassable for months. Siblings Zella (left), Roy (right), and Ferris English could walk the 240-acre parcel without once stepping on the ground. Carl English cleared trees using a drag saw, but the process would take 30 years to complete. Much of the wood went to fuel the steamships at Fisher's Landing. (Photograph by Carl English; courtesy Gene English.)

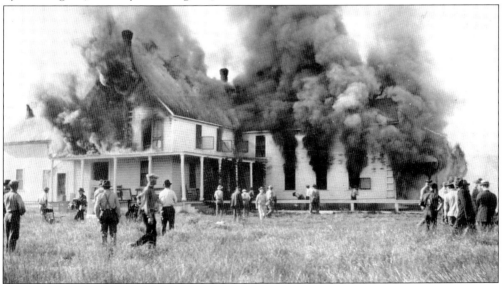

In 1880, fire broke out in the thick forest separating Fourth Plain and Mill Plain. It burned down to the Duback place, and the whole neighborhood worked to fight the flames. A constant danger, fire took storehouses and farmhouses, and the problem only got worse after the great gale, which felled up to 90 percent of the area's remaining timber. This photograph, taken by Mildred Frost in Loyalton, California, illustrates how quickly all was lost. (Courtesy Pat Forgey.)

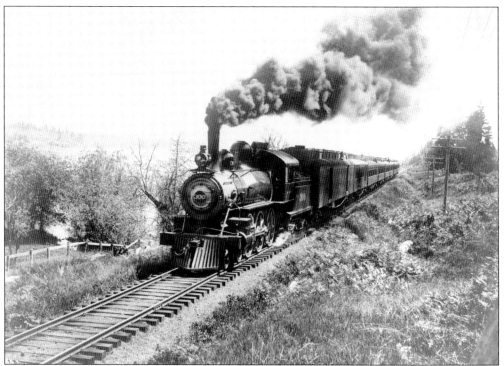

The Spokane, Portland, and Seattle Railway Company completed the Northbank Railroad on November 17, 1908. The 231 miles of track, 13 tunnels, and 2 bridges cost $4.5 million. Shipping was big business. In 1908, there were 24 steam railroad companies and 4 electric train companies networking Oregon and the Columbia River communities, for a combined track total of almost 2,000 miles. (Courtesy Library of Congress.)

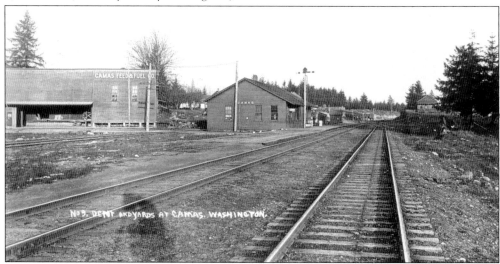

The Northbank Railway ran straight through Fishers Quarry, necessitating the demolition of the original Fisher house. Train fare from the Camas depot (pictured) into Fishers was 25¢. In those days, a potential passenger could flag the train and it would stop and pick them up. May Simmons and her friends once flagged the train one mile from home. The cost? A nickel each for the trip. (Courtesy Two Rivers Heritage Museum.)

Carl English built steam, electric, and gasoline engines, as well as this "car" in 1894. It had a chain drive, a tiller bar for steering, and a top speed of 12 miles per hour. Early gasoline engines were gravity-fed and puttered out uphill. Drivers were forced to climb hills in reverse. At that time, as Gene English observed, "just the fact that it moved, you were happy." (Courtesy Gene English.)

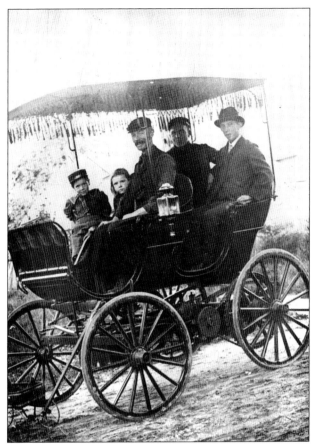

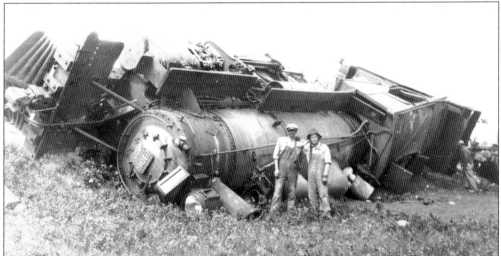

Early cars were impractical, but trains had their own problems. The Oregon Railroad Commission reported 272 people injured or killed in 1907–1908. Derailments, such as this one in Lacamas about 1910, were the worst, followed by accidents from jumping on or off the trains. The hobos who wandered the rails found kindness in Fishers. Ann Fisher Simmons fed and even clothed them before sending them on their way. (Courtesy Two Rivers Heritage Museum.)

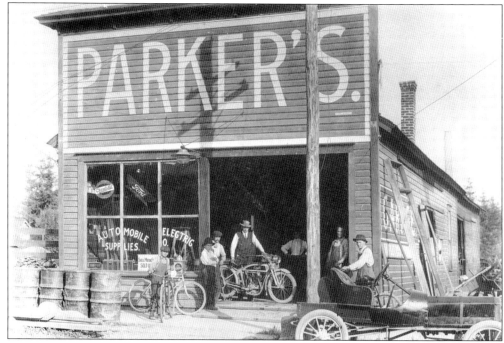

Fishers Landing homesteader David C. Parker owned the first Ford dealership in Camas. Thomas Gentry remembers the hand cranks in those first cars. A person cranked an iron rod to start the engine, and when it caught it had enough kick to fling him backward. If he was not careful, or simply not lucky, he could break his arm. The old Model A Fords got 20 miles per gallon. (Courtesy Two Rivers Heritage Museum.)

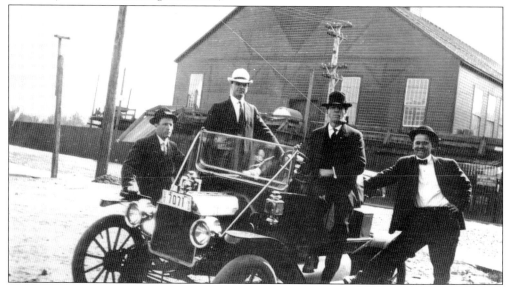

Earl Knapp, ? Farnsworth, Leon Wupin, and Joe Wupin, in no particular order, pose to commemorate the delivery of a prized new car in Oregon around 1913. A magnificent luxury, cars quickly replaced the horse and wagon. Thomas Gentry occasionally drove his father's car in high school. "Well shoot," he explains, "the fun was to get in the car and go up on Prune Hill and neck." (Courtesy Two Rivers Heritage Museum.)

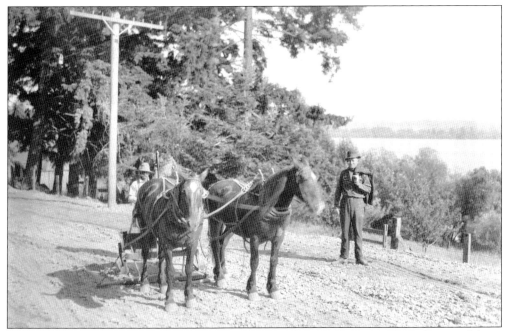

The first roads in Fishers Landing were dirt tracks winding between farms. Fisher Road (now 164th) was muck most of the year. People carried planks in their wagons, laying them down across the muddy areas in order to pass. Neighborhood residents pitched in to build the old Evergreen Highway in 1920. Here Charlie Pound (left) pulls scrapers by horse team to smooth the road. (Courtesy Thomas E. Gentry collection.)

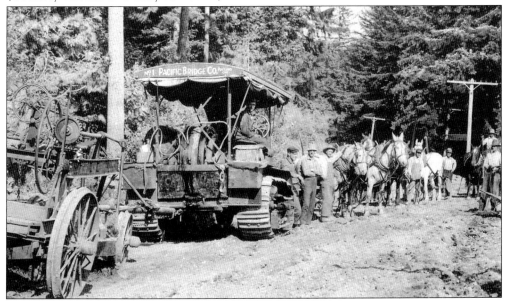

To build the Evergreen Highway, horse-drawn wagons hauled in gravel, sand, and 100-pound bags of concrete. Everett Gentry ran the concrete mixer, and each load of concrete built another two to five feet of road—a slow process. This Pacific Bridge Company machine was a track-laying tractor. Using the wheels on top, workers adjusted the scraper blade up or down to smooth the road. (Courtesy Thomas E. Gentry collection.)

BLAIR'S

Dealers in

❖ ❖ General
Merchandise

❖ ❖ EAST MILL PLAIN

The area's primary commercial center was in Fishers, but businesses dotted the Mill Plain area, with many farmers engaged in agricultural businesses as well. The prolific Blair family owned a number of local stores, including Blair Brothers Lumber in Orchards, opened about 1910. Rome J. Blair established the Camas Meat Company and Camas Ice Company in Camas around 1911. (1926 *Wauna* yearbook; courtesy Union High School.)

The old Blair Store was sandwiched between the old Mill Plain School (now a duplex, far left) and the Blair house (now a realty office, center) on Mill Plain and 164th. The store was a popular gathering place; community members came in, took what they needed, and paid on credit. A 1946 advertisement reads, "Blair's Store. Groceries, Meats, Ice-Cream, Gas, Oil, Feed, Fruits, Candy, Beverages. East Mill Plain." (Photograph by R. Fairhurst, 2008.)

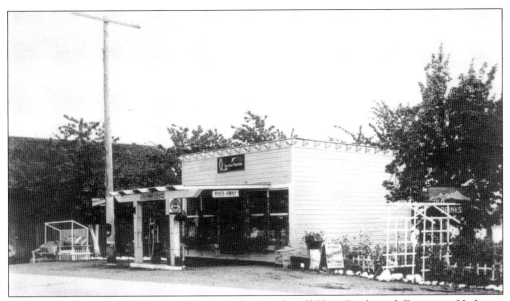

As cars repeatedly got stuck in the gummy Fishers mud, Mill Plain Boulevard, Evergreen Highway, and Fisher Road underwent car-friendly grading and improvements. Everett Gentry opened the Rockaway service station (pictured) on Evergreen Highway, and his son Thomas became an expert with all kinds of engines. Thomas built and ran Gentry's Landing, a service station for boats, on the Columbia River and established an unrivaled reputation for mechanical expertise. (Courtesy Thomas E. Gentry collection.)

Trees and foundations are all that remain of George Allen's Pumpkin Center, a gas and grocery stop operating next to Fishers Cemetery from 1910 to the 1950s. A postmaster and Grange master, George Allen built his store from a wood and boardwalk structure into a thriving community center. He rented one-room cabins, with a privy out back, to those starting out or just down on their luck. (Photograph by Betty Ramsay; courtesy Two Rivers Heritage Museum.)

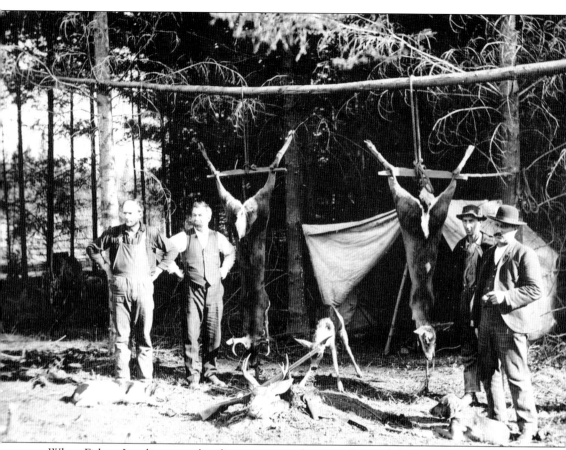

When Fishers Landing was a bustling commercial center, Camas did not exist—and neither did Lacamas Lake. Those who homesteaded in today's Camas area registered their claims as being either in Fishers or Washougal. This hunting party has camped smack in the center of current downtown Camas, right near city hall. The area was prized for its game. Though Camas came late onto the scene, when it hit, it hit big. In 1883, the La Camas Colony Company purchased the land surrounding Lacamas Creek and set about building a dam and the waterworks to run a paper mill. The next year, Chinese workers dug the 2,000-foot tunnel that would bring "Lake La Camas" water to the mill. In April 1884, construction of the first 100 homes was underway. After the economic downturn of the 1880s, the project drew a huge welcome. In May, the *Vancouver Independent* declared, "Money is again plenty, and per consequence everybody is happy." (Courtesy Two Rivers Heritage Museum.)

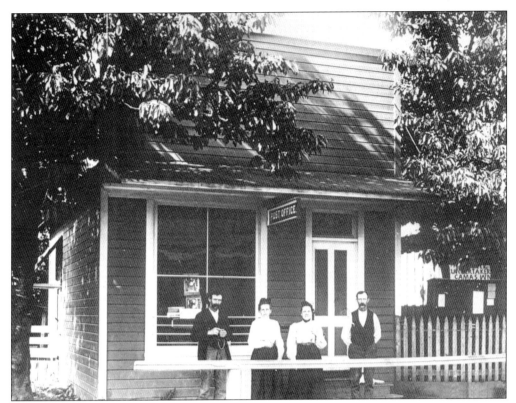

Henry M. Knapp set up Camas's first post office, the short-lived South Plain office, in his Grass Valley home in 1874. In 1884, the Camas Post Office opened adjacent to an undertaker. Henry M. Knapp, Hilda E. Knapp, and Henry A. Knapp all served as postmasters between 1897 and 1931. Those shown here are unidentified. (Courtesy Two Rivers Heritage Museum.)

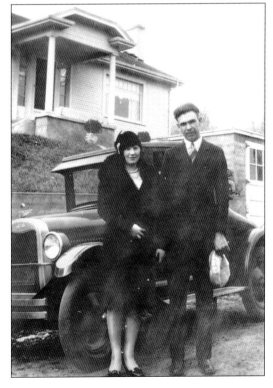

The Camas and Fishers Landing boundaries overlap, especially in Grass Valley and Prune Hill. Fishers families worked in the paper mill, founded churches, started businesses, and built schools in Camas. Charles and Lola Bybee Kramer built this house on Sixth Street. Lola's sister Vera poses in front with her husband, Bill Mayfield. Bill and Vera announced their wedding on October 12, 1929, by telegram: "We were married at twelve thirty today." (Courtesy Pat Forgey.)

Antone and Elizabeth Young settled in the Harmony area in 1872, with their children marrying Steins and branching out into Mill Plain. Antone and George Young owned the Brewery Saloon in Vancouver, advertising delivery "to any part of the city in kegs or bottles." Henry M. Knapp also conducted business in Vancouver. In 1887, the newspaper reported his "new building on Clara Street." Alton Young is pictured here about 1925. (Courtesy Patsy Ferguson Sleutel collection.)

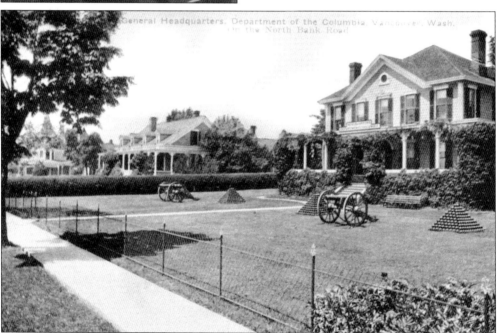

Many Mill Plain farmers supplied Fort Vancouver, and as Vancouver grew, Fishers Landing families maintained strong ties to that city. In January 1913, a large hollow was found in the famous Hudson's Bay apple tree. Clark County Fruit Growers Association president Chat Knight, whose family came to Fishers by wagon train, filled the cavity with sand and cement to help preserve it. (Postcard by the Portland Post Company; courtesy Patsy Ferguson Sleutel collection.)

Presbyterian Church, Vancouver, Wash.

Well-to-do families typically owned a house in town and a farmhouse in the country. People visited between them, keeping in touch using postcards like this one sent in 1909 and inscribed, "Dear Sadie: This is one of the big buildings in Vancouver, in fact it is where I attend Sunday School. Ha! Ha! I suppose you are enjoying this pleasant weather as I am. Love, Lucy." (Postcard by Sprouse and Son; courtesy Patsy Ferguson Sleutel collection.)

Descended from Bybees and Dubacks, three-year-old Patsy Frost came from a strong tradition of educational leaders. Patsy grew up on Mill Plain and graduated from Union High School. In 1947, she represented the school as a VanGatta Girl. The VanGatta Girls, one from each Clark County high school, were goodwill ambassadors to the Portland Rose Parade. The girls traveled to Seattle and rode in a yacht and helicopter. (Courtesy Pat Forgey.)

Early on, everybody was in everybody else's business in the social as well as economic sense. Prominent families especially earned mention in the Vancouver newspaper. In 1884, the *Vancouver Independent* reported that Silas D. Maxon was hanging shelves in his store. What and where Marie Whipple was studying and where Rita Blair visited for Thanksgiving seemed too important not to mention in 1912. (Postcard by Sprouse and Son; courtesy Patsy Ferguson Sleutel collection.)

Sadie Blair saved colorful advertising cards as souvenirs, including this one from Vancouver merchant E. Brandon, who lists cigars, confections, and tobacco for sale about 1890. Long or short visits to Vancouver were commonplace for many in Fishers Landing. In 1882, Amelia Knight celebrated her 64th birthday there, with the *Vancouver Independent* reporting that "the Vancouver City Band gave her a complementary [*sic*] serenade." (Courtesy Patsy Ferguson Sleutel collection.)

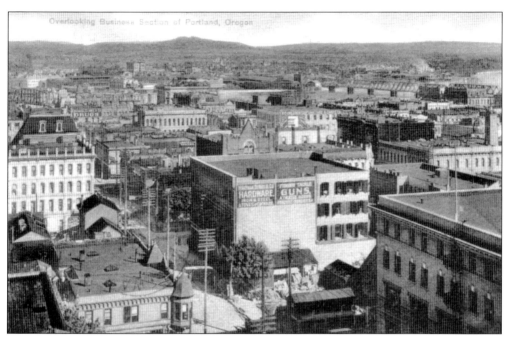

By riverboat or train, Fishers connected with Portland; businessmen were well known there, and excursions were common. Besides, it was more fun to shop in Portland than stay home and do chores, a sentiment expressed on this card, postmarked 1909. "Hello Sadie. I suppose you are having a fine time. I am not. I have been picking prunes. Lizzie." (Postcard by Sprouse and Son; courtesy Patsy Ferguson Sleutel collection.)

Lewis Love was among those with businesses in both Fishers and Portland. He owned a hotel, mill, and a store on Front Street. John Simmons also enjoyed city living. He married Caroline Wagenblast, rented out his farm, and bought a house in town. Sadie Blair collected advertising cards from Portland, just as from Vancouver. These cards, produced about 1890, advertise Portland tailor Arthur Kohn and Monongahela white rye. (Courtesy Patsy Ferguson Sleutel collection.)

World War I, pest infestations, and the 1916 ice storm decimated Clark County's prune industry, including this Mill Plain orchard with packing crates, seen around 1915. Fishers Landing remained productive, as potatoes, hayfields, beef cattle, and dairy farms replaced many prune orchards. In the 1930s, a wave of migrants arrived, comprised of those who had fled the Depression and the Dust Bowl. They were called "Okies" and "fruit tramps." Left with nothing, they looked to the green fields of the Pacific Northwest for a chance to begin again. They camped in the woods, in tents and in cars, worked menial jobs in the fields, and labored picking and packing fruit. Bob Hitchcock Sr. remembers a man who came to the farmhouse door to ask for a sandwich as just one of many. Their numbers were intimidating. These workers stressed local schools and relief organizations, but they were industrious and determined. Many were educated and skilled in farming and dairying. As things settled out, the immigrants found new luck, purchased farms, and married into the community. (Courtesy Patsy Ferguson Sleutel collection.)

# *Three*

# FOUNDING A STATE

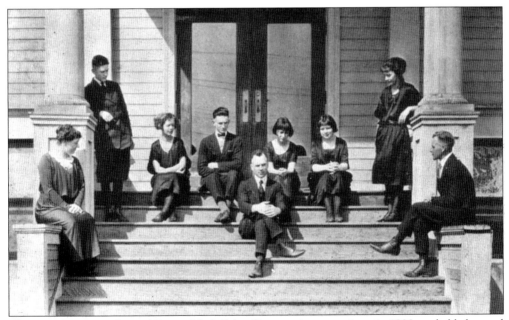

These students, members of Camas High School's executive committee in 1923, probably learned their leadership skills and political acumen on their grandfathers' knees. The Van Vleet, Knight, and Dibble families all made their mark in Clark County politics. Pictured from left to right are Elsie Van Vleet, Bernard Newby, Gladys Knutson, George Jefferson, H. B. Ferrin, Faye Butler, Lillie Knight, Ruth Dibble, and Lester Strong. (The *Waunomah*; courtesy Two Rivers Heritage Museum.)

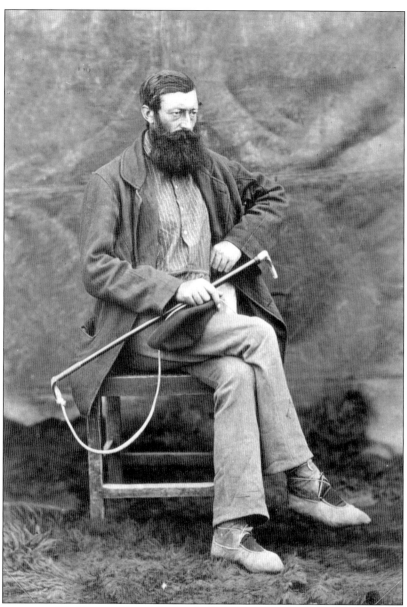

Clark County was Washington State's bedrock; from its citizens came the territory's first civic foundations. Lady Island's William Goodwin served as the initial Clark County judge and commissioner in 1850 and 1851. William Simmons presided over the first County Commissioner's Court in 1851, serving from 1851 to 1852 and again from 1854 to 1857. He was coroner in 1853. Silas Maxon held the position of county treasurer from 1850 to 1853, and Henry M. Knapp was auditor from 1852 to 1853. The first voting precinct in Fishers Landing was called Michises (changed to Preston Precinct in 1854), with Joel Knight serving as the initial judge in 1851. Solomon Fisher worked as Preston Precinct's justice of the peace from 1857 to 1861, with Ervin J. Taylor following. County commissioners formed seven road districts and six school districts in 1852. Clark County's first grand jury included William Simmons, Solomon Fisher, and Thomas Fletcher, with Job Fisher as petit juror. Here John Keast Lord, a Northwest Boundary Survey team member, typifies the look of the early territorial statesman about 1860. (Courtesy Library of Congress.)

Thomas Fletcher, Joel Knight, Silas Maxon, William M. Simmons, Henry M. Knapp, and other Fishers Landing residents relied on their political challengers and cohorts to help them build Washington Territory. Men like Vancouver's Columbia Lancaster, legislator and U.S. surveyor Lewis Van Vleet (pictured), and William Goodwin (more associated today with Camas-Washougal than Fishers) were tightly knit among them.

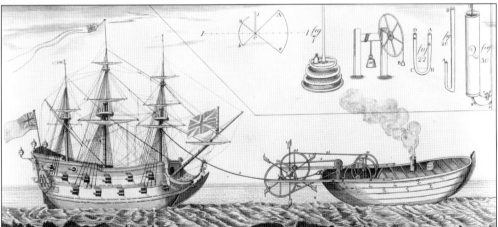

The British surrendered Washington in 1845, but the Hudson's Bay Company remained powerful. The firm and its employees claimed continued landholdings in the territory, including property at Fishers Landing. This spurred men like Thomas Fletcher to action in 1853. Tempers flared, name-calling ensued, and "the Company" finally backed down. This patent application sketch, showing an American warship towing away a British man-o'-war, encapsulates that era's pro-American sentiment. (Courtesy Library of Congress.)

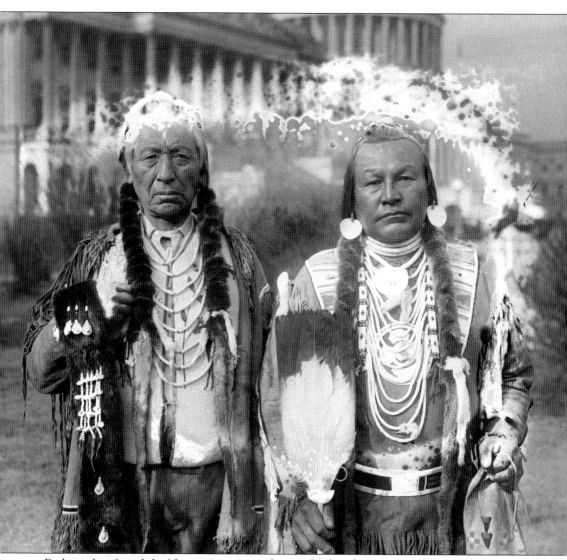

Early settlers feared the Native Americans despite the fact that many of the cultural exchanges were friendly ones. Thomas and Susanna Fletcher moved from Lacamas Creek to Lady Island in 1859. In the 1860s, when Thomas was gone from home (perhaps during his second term in the territorial legislature in 1862), a Chinook chief came to the house and requested Susanna's help for his wife, whose labor was not progressing well. A skilled midwife, Susanna grabbed her bag and went with him to the village across the river. There she helped deliver the baby safely. As a gesture of thanks, tribe members escorted Susanna home with a complement of seven canoes and an honor guard of torchbearers. Yet as the settlers streamed west, relations between the two cultures were increasingly strained. War broke out with the Yakima and Nez Perce Nations in 1855, and Thomas Fletcher and his sons William and John joined the Clark County Rangers to fight. After the Yakima War, the nations of the Columbia were moved onto reservations. Yakima Indian chiefs are seen here in 1927. (Courtesy Library of Congress.)

Hamilton Maxon resigned from the territorial legislature to muster the Washington Mounted Rifles during the Yakima War. He led the Southern Battalion, but tempers erupted between Puget Sound leaders and Captain Maxon over who had primary authority. In March 1856, Maxon's men rode into a Mashel River Indian camp, killing women and children, shooting them as they fled. The event was called Maxon's Massacre. (Photograph by Remington Prints; courtesy Library of Congress.)

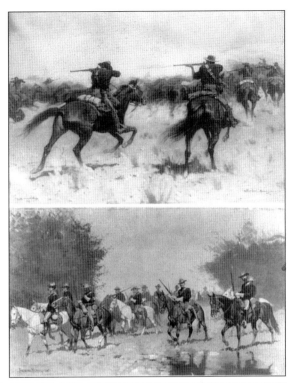

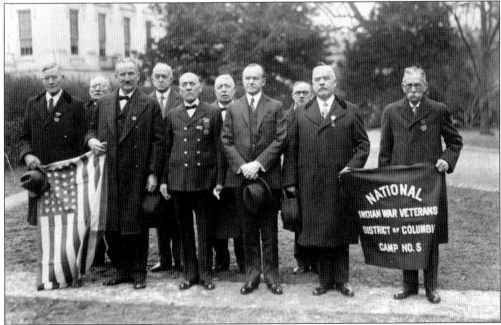

A number of Fishers Landing settlers fought in the Rogue River, Cayuse, and Yakima Indian Wars. A 1st lieutenant under William Strong, Ervine Taylor later fought with Hamilton and Silas Maxon in the Washington Mounted Rifles. Jacob Duback served with Company H in the Rogue River War, and Henry M. Knapp joined the Clark County Rangers. The national Indian War survivors pose with Calvin Coolidge in 1927. (Courtesy Library of Congress.)

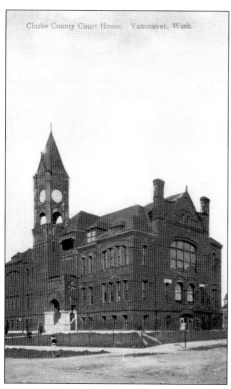

The first Clark County Court met at Amos Short's home in Columbia City (renamed Vancouver in 1855). Fort Vancouver and Hudson's Bay authorities, however, forbid locating the county seat there. A new site was selected at Fishers, to be ratified by Clark County voters. But in 1855, before a vote was made, construction began in Vancouver anyway. The original courthouse burned in 1890. The second structure is seen here in 1910. (Courtesy Patsy Ferguson Sleutel collection.)

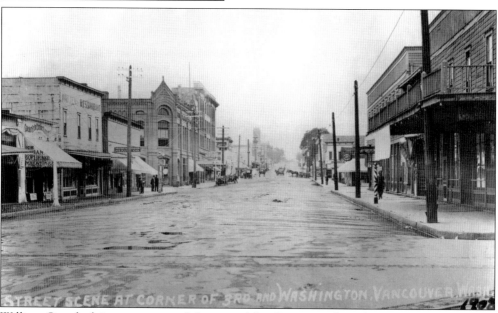

William Crawford, incorporator and director of the Commercial Bank of Vancouver and then the Vancouver National Bank, got his start as a merchant and assistant postmaster in Fishers. In 1883, he started the hugely successful W. P. Crawford and Company with his brother in Vancouver. An Odd Fellow and a Mason, Crawford served six times on the Vancouver City Council. This photograph of downtown Vancouver was taken in 1908. (Courtesy Patsy Ferguson Sleutel collection.)

David P. Thompson owned a large farmhouse in Fishers at what is now Cascade Park. Thompson was vice president and director of the Oregon Railway and Navigation Company, twice Portland's mayor, and an Oregon Territorial legislator from 1866 to 1872. In 1882 and 1889, he served as envoy to Turkey.

David and Mary Thompson had three children, and their son Ralph, who had epilepsy, lived primarily on the Fishers farm (pictured). Norman Powell spent Thanksgivings at the Thompson place, as his aunt and uncle were caretakers. At five stories high, the farmhouse was the nicest in Clark County. The house and barns were demolished to make way for State Route 14. Only the big redwood tree remains. (Courtesy Norman Powell.)

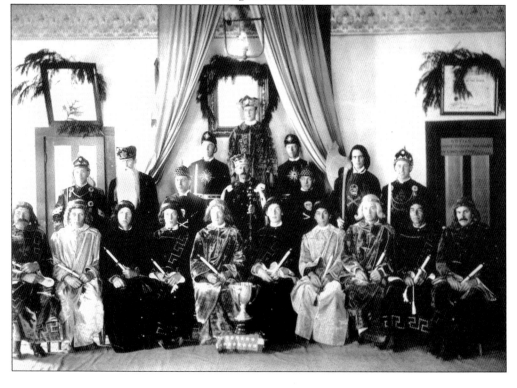

**SEMI - ANNUAL REPORT**

OF

Lodge, No. *Three* ... I. O. O. F.,
OF WASHINGTON,
For the Term ending *June 30* 18*77*

Regular Meeting of the Lodge in each week is on *Thursday* evening.
Located at *Vancouver* in the County of *Clarke, Wash. Ty.*
Money inclosed is $ *19.50*
Letters to the Lodge are to be directed to Mr.
*Geo. W. Brownmiller*
P. O. Box *77*

OFFICERS ELECTED.
Newly elected officers will write their own names.

☞ NEW OFFICERS SIGN. ☜
*Fred W. Bier* .....N. G.
.....V. G.
*G. W. Brownmiller* ..... Sec'y.
*William Ranck* .....P. S.
*S. D. Maxon* .....Treas.

THE REPRESENTATIVE TO THE GRAND LODGE IS

Silas D. Maxon came north from the goldfields in 1850, settling on 360 acres in Fishers on the Columbia River, in today's Cascade Park. A widower with five small children, Silas was nevertheless a dynamic civic leader. Clark County's first treasurer, he also served as treasurer and noble grand for the Vancouver International Order of Odd Fellows. Silas's children attended Mill Plain School starting in 1857. (Courtesy Washington State IOOF.)

A benevolent order, the IOOF pledged to help widows and founded orphanages all over the country. These members of the Northbank IOOF won the silver cup for dramatizing values of brotherhood and faith in 1910. In addition to being a territorial legislator in 1860, Silas Maxon was a revered member of the Clark County community. When he died, he lay in state at the Odd Fellows Hall in Vancouver. (Courtesy Two Rivers Heritage Museum.)

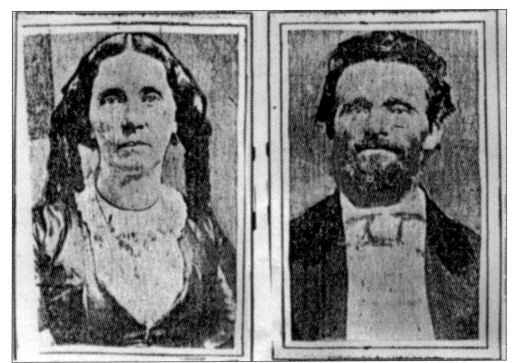

Joel and Amelia Knight crossed the Oregon Trail in 1853 with eight children, their son Wilson born along the way. They settled on the Columbia River near today's 192nd and planted the first fruit orchards at Mill Plain. Joel had studied medicine in Boston, thus naming the couple's firstborn son Plutarch. Their second son, Jefferson, drowned in the Columbia. Joel served as a territorial legislator from 1854 to 1857 and 1864 to 1865. (Courtesy Two Rivers Heritage Museum.)

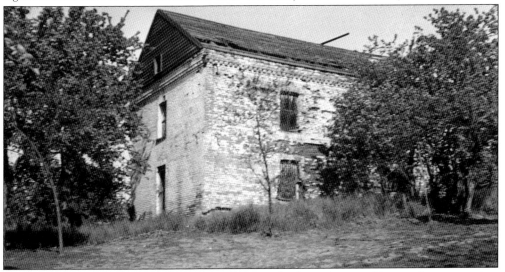

Three Fishers Landing men were central to early law and order in the state. Territorial representatives Thomas Fletcher and Joel Knight raised funds to improve the territorial jail (pictured), built prior to 1855 and for years located on McNeil Island at Steilacoom. Silas Maxon, justice of the peace in Fishers and Vancouver, built Clark County's first jail in 1854. Previously, prisoners had been tied out in the yard. (Courtesy Library of Congress.)

they can be placed at a cost to the District not to exceed $15.00 for the two. Attention then being called to an Article over the Signatures of S. S. Cook & A. J. Remington. in the Vancouver Independent of Oct 29th 1896 reflecting directly upon the integrity of a certain member of this Board, and indirectly upon the entire Board, to the effect that the Republican Club of Preston Precinct had been unjustly and intentionally locked out of the School House of this District, with the intent to deprive them of the use thereof. Now therefore We the Board of Directors of District No. 4 of Clarke County, in our Official capacity, do hereby denounce such Charges and Strictures, as predicated upon an unjust inference and that the writers of said article have therein done violence to common courtesy, and have by hasty and ill advised (otherwise Malicious) publication, shown an entire absence of that equitable judgment which would mete to another that fair treatment which they would themselves desire if relative positions were reversed, and that the language used was calculated to deceive the Public in regard to the true facts in the case, which were as follows Viz the ~~Board of Directors~~ School

Continued on Page 86

The epic political scandal of 1896 unfolded at the Mill Plain schoolyard. Apparently, when Samuel Cook and the Republicans arrived for a meeting there, the Populists (with the keys to the schoolhouse) were nowhere to be found. Locked out and frustrated, Cook and A. J. Remington wrote a testy letter to the *Vancouver Independent*. This excerpt from the Mill Plain School Board minutes details the board's response. (Courtesy Union High School.)

Washington achieved statehood in 1889. Samuel S. Cook (second row, fourth from left) and Hannibal Blair (first row, fifth from left) served in the first state legislature. A physician, Blair took pride in raising the state standards of medical practice. Cook served on the following committees: Commerce and Manufactures; Hospital for the Insane; Assessment and Taxation; State, County, and Municipal Indebtedness; and State Lands. (Courtesy Washington State legislature.)

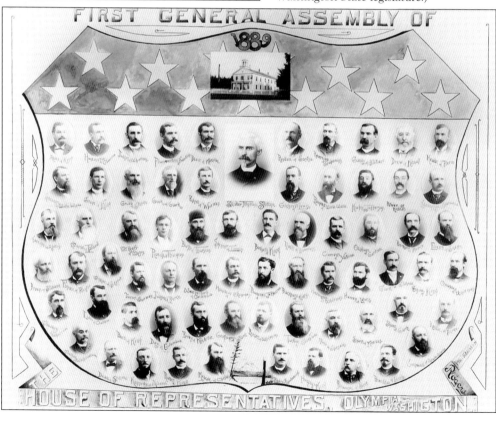

FIRST GENERAL ASSEMBLY OF 1889

THE HOUSE OF REPRESENTATIVES. OLYMPIA, WASHINGTON

Monkey business or not, the people of Fishers Landing were in earnest about politics, though Samuel Cook was perhaps slightly more fervent than most. In 1890, the *Vancouver Independent* reported that Cook "introduced a resolution to expel three newspaper reporters from the halls of the legislature, because they let the anti-boodle cat out of the bag." Vancouver representative J. D. Geoghegan called the resolution frivolous, and Cook threatened to resign. (Courtesy Library of Congress.)

Edward L. French owned extensive orchards on Mill Plain and an enormous prune dryer, later a cannery, at Ellsworth. French, with his Hollywood and Happy Breakfast prunes, competed internationally with California, which exhibited a giant bear made of prunes during the 1905 Portland World's Fair. French (first row, fourth from left) served 12 years in the state legislature, became state director of agriculture, and ran for governor. (Courtesy Washington State legislature.)

79

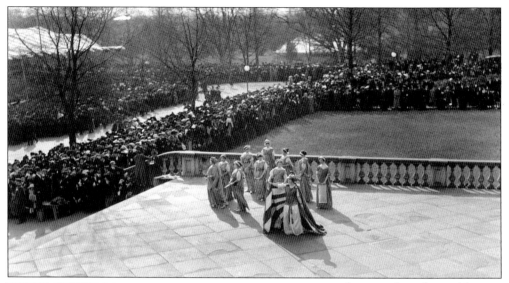

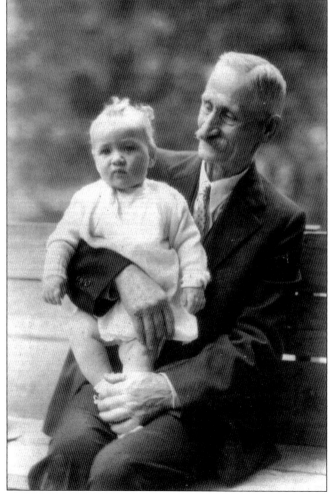

As a member of a wealthy and well-connected family, George A. Whipple received the best possible education before he settled onto a farm in the Harmony area in 1877. George's sister Ella was a politically active, vocal suffragette in 1889. Her mother, Charlotte, had spoken out for temperance in the early 1850s. Here women stage a temperance parade in 1913. (Courtesy Library of Congress.)

Washington women won the right to vote twice, in 1883 and 1888, before it stuck in 1910. Henry M. Knapp, a state legislator in 1859 and 1866, gave a powerful speech regarding suffrage—powerful because he was able to articulate the different points of view and crystallize the problem as he saw it. His efforts would greatly benefit his great-granddaughter, pictured with Henry A. Knapp in 1935. (Courtesy Two Rivers Heritage Museum.)

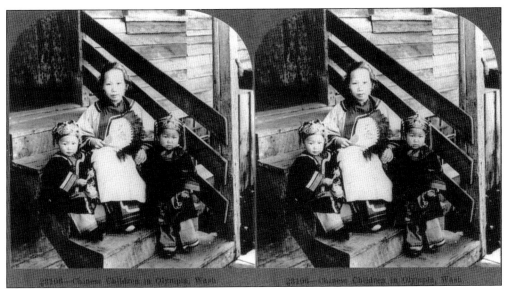

This Chinese family, shown in Olympia in 1919, and others came to the territory in search of new opportunities. They cooked at Fishers Quarry, labored for the paper mill, and worked as domestic launderers and cooks. A group of Chinese lived in a cabin in the Harmony area and sold cordwood. Solomon Fisher took the wagon up each weekend and filled it. (Stereograph by Keystone View Company; courtesy Library of Congress.)

Clark County was generally tolerant toward the Chinese; in fact, the first prisoner in the new jail was imprisoned for harassing Chinese launderers in 1883. Though Chinese immigrants and Westerners interacted on the job, socially they remained separate. This 1928 photograph of schoolchildren in Happy Valley, Oregon, is remarkable for two things. First, Asian children are part of the class. Second, teacher Mildred Frost is expecting. (Courtesy Pat Forgey.)

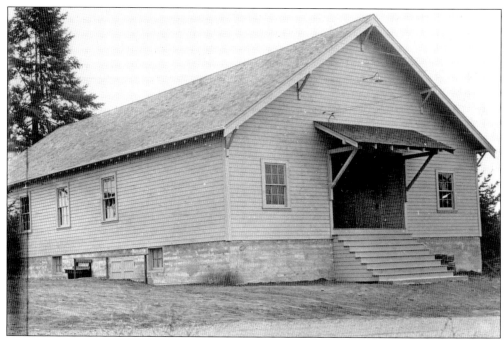

In 1874, Henry M. Knapp founded the Mill Plain Grange, and S. T. Burns organized the Preston Grange in 1889, naming it for the local voting precinct. Fishers Grange replaced both in 1907. In 1973, Fishers Grange was moved to north of Mill Plain Boulevard from near State Route 14. The c. 1930 dirt track in front of Fishers Grange Hall is today's 164th Avenue. (Photograph by Carl English; courtesy Gene English.)

George Allen was the first master at Fishers Grange. Local Grangers who held state office included Vida English, ceres; Ruth Scott, chaplain; Thomas Gillihan (Preston Grange), chaplain; and Henry M. Knapp, deputy master of the Oregon State Grange in 1874. These Fishers Grange picnickers, seen about 1930, may include a number of founding families: Allen, English, Manary, Tiffany, Bybee, and Brown. (Photograph by Carl English; courtesy Gene English.)

Dances were the primary fund-raising activity at Fishers Grange, enabling it to be politically active and contribute to good causes. The Tempo Kings played every Saturday night in 1955. The band included, from left to right, Ross Turbush (trombone), two unidentified people, Jack Frost (trumpet), Russ Ainsworth (bass), Rudy Lundquist (saxophone), and Alice Powell (piano). Other members were Al Lightheart (drums), Jess Frost, and Jerry Craig. (Courtesy Pat Forgey.)

These Grangers may have been celebrating the 40th anniversary of Fishers Grange in 1947—or perhaps Independence Day, with Abe Lincoln standing center. Revelers included the following, from left to right: (first row) Blanche, Muriel, Irene, Gladys Shand, Dora, May, Vivian, Ida, and Ora; (second row) Vida English, May, Edna Hawk, Rose, unidentified, Betty Rupe, Bobbie, Mildred Frost, Agnes, Ruth Scott, Ethel, Margonette, and Cherrie. The men are unidentified. (Courtesy Pat Forgey.)

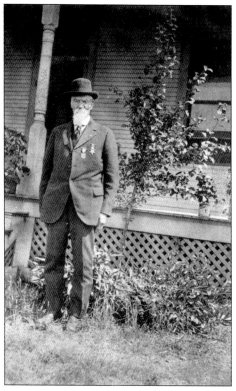

Fishers Landing's Civil War veterans included Amana Randall, Gideon Gillihan, and John Timmons. Brothers Pinkney and Frame Blair served in the Missouri Volunteer Cavalry. This veteran, either Pinkney or Frame, stands at the Frame Blair home on Mill Plain. He wears a Missouri ribbon, a Grand Army of the Republic membership medal (Frame joined the Ellsworth post), and likely a Missouri state medal. (Courtesy Patsy Ferguson Sleutel collection.)

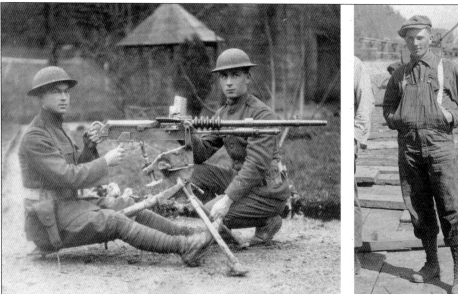

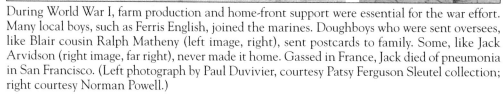

During World War I, farm production and home-front support were essential for the war effort. Many local boys, such as Ferris English, joined the marines. Doughboys who were sent oversees, like Blair cousin Ralph Matheny (left image, right), sent postcards to family. Some, like Jack Arvidson (right image, far right), never made it home. Gassed in France, Jack died of pneumonia in San Francisco. (Left photograph by Paul Duvivier, courtesy Patsy Ferguson Sleutel collection; right courtesy Norman Powell.)

Shipbuilding was vital to the war effort during both world conflicts. Locally, Kaiser Shipyards needed skilled workers, and people from all over the country showed up to help get the job done. These workers required infrastructure support, housing, schools, and medical care. Fishers Landing contributed labor and support, but there were risks. Saul Fisher died in a shipyard accident in 1944. (Photograph by Alpha Litho Company, 1917; courtesy Library of Congress.)

Thomas Gentry's uncle Chester Stevens served many years aboard the *Oklahoma*. May Simmons Gentry sewed navy uniforms for her boys Thomas (left image, left) and Ernest around 1920, as they wanted to be just like "Uncle Steve." In World War II, Thomas Gentry donned a real uniform of his own (right image). A machinist's mate, he spent three years patrolling the coast from Portland to Alaska. (Courtesy Thomas E. Gentry collection.)

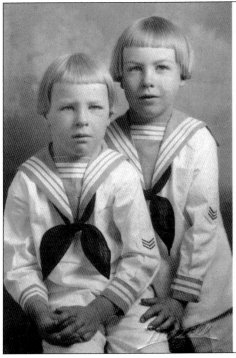

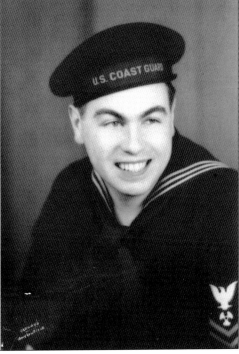

Verle Ferguson, at home on Southeast First Street, joined the coast guard in 1943 and sent this note to his wife, Doris: "Dearest Punkie, Got here o.k. this AM. Sure am tired today as I didn't get hardly any sleep. The toughest and wreckiest old tub on the line. Sure is a wreck but got me here and I love you today. Write, your sailor." (Courtesy Patsy Ferguson Sleutel collection.)

Serving out of Florence, Oregon, Verle was close enough for frequent visitors. This party included Virginia and Dick Emery (left), Steve and Beverly Strable (center), and Verle and Doris Ferguson. Other World War II veterans were Bob Hitchcock Sr. and Norman Powell, both navy aviation machinists, and Don Hitchcock, who served with Patton's Third Army in Germany and Austria. In Vietnam, Harry Friberg Jr. was a Green Beret, and Bob Hitchcock Jr. served with the Army Corps of Engineers. (Courtesy Patsy Ferguson Sleutel collection.)

## *Four*

# TIMBER, ROCK, PRUNES, AND PAPER

Fishers Landing tended to do things big: a giant prune and fruit canning industry, a busy river landing, and forests so thick George Whipple once got lost a few hundred feet from his cabin—not to mention a quarry that produced millions of tons of rock. With so much activity, politicians liked to keep the people happy—like these congressmen enjoying fruit pies in 1926. (Courtesy Library of Congress.)

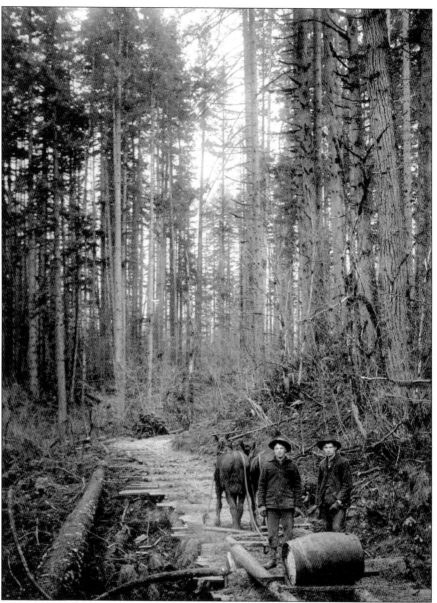

A sawmill at Ellsworth and another at Camas bookended the eastern and western boundaries of the Fishers Landing area along the river in 1851. Both mills were originally built by the Hudson's Bay Company, and both burned. Lewis Love rebuilt the Ellsworth mill, and Hamilton Maxon reconstructed the one at Camas, as the site was located on his donation land claim. Hamilton's brother Silas was a partner in the La Camas mill. When that mill burned as well, the brothers lost 125,000 board feet of lumber. Still, lumber production was a premium industry, and lumber mill owners got rich. Lucia mills cut 25,000 board feet each day for a total of 3.5 million in six months. Its employees worked 11-hour days, seven days a week. In this c. 1900 photograph, a two-horse team led by Ed Nerton and Bob Sticher drags a barrel along a mud and timber road near Lucia Falls. Thomas and Elizabeth Nerton were among the original settlers of Fourth Plain. Their daughter Mary E. Nerton married Frame Blair and raised a family on Mill Plain. (Courtesy Patsy Ferguson Sleutel collection.)

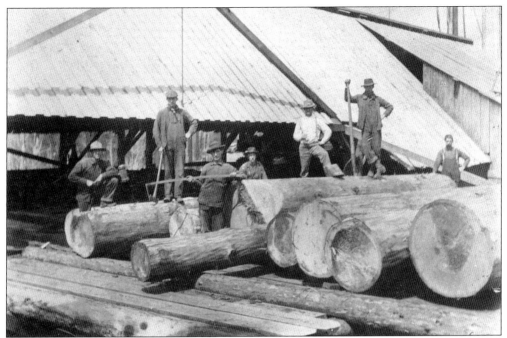

Lumber mills cropped up everywhere. Mobile mills moved among the Mill Plain farms, such as this one at Mill Creek near Friberg/Strunk Street. In 1952, Edward Bolds started Bolds Lumber on an old quarry dock on the Columbia River, then one of 50 lumber mills in Clark County. Bolds is now Columbia Vista Lumber, a specialty mill and exporter, and one of only two mills still operating in the county. (Courtesy Two Rivers Heritage Museum.)

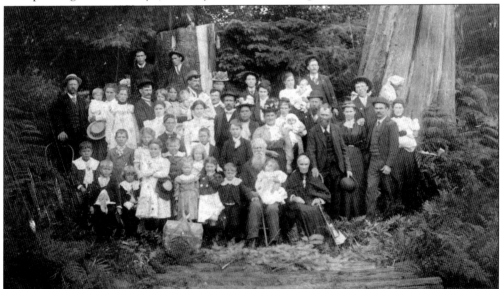

An unidentified family gathers around 1900 among the towering trees that awed and plagued the pioneers. The trees were cleared, but "stump farms" abounded, some with cabin-sized stumps. Some farmers turned to dynamite as a solution. In just the right amount, dynamite popped the stump up and out, roots and all. But too much bang blew it to smithereens and left a mess still rooted in the ground. (Courtesy Two Rivers Heritage Museum.)

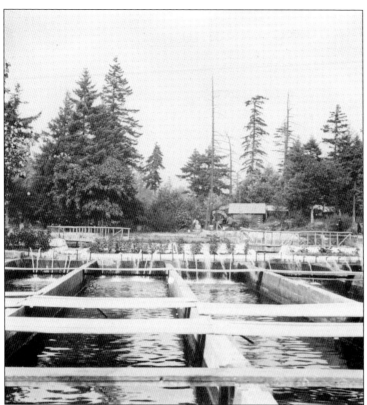

Fish populations in the Columbia River seemed inexhaustible. Settlers told of scooping fish from the river in buckets, and of stern-wheelers churning up so many fish the decks were inundated. By the 1890s, however, with fish populations dwindling, conservation began. The Vancouver Trout Hatchery on Evergreen Highway, pictured about 1920, is now part of the Biddle Natural Preserve and the Columbia Springs Environmental Education Center. (Photograph by Carl English; courtesy Gene English.)

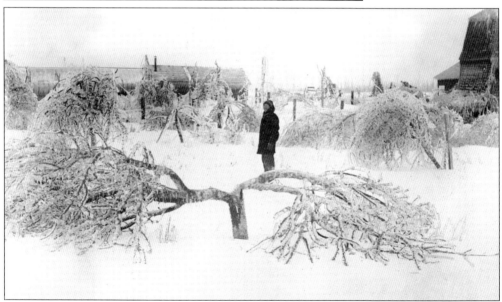

Clark County was once the prune capital of the world, with many prune dryers in Fishers Landing, including seven on Prune Hill, the Gillihans' dryer in Fishers, and Mat Blair's dryer on the corner of 164th and Mill Plain, which ran into the 1940s. Prunes began to decline after the 1916 ice storm damaged orchards across the county. Carl English's young orchard (pictured) never recovered. (Photograph by Carl English; courtesy Gene English.)

Henry Lewis Pittock worked as a typesetter for the cash-strapped Thomas Dryer, printing the front-line reports Dryer dispatched during the 1855 Yakima War. With true business acumen, Pittock accepted a financial interest in the paper instead of wages. He soon owned the company. Pittock planned to make the *Oregonian* the leading newspaper in Oregon. And for that, he needed paper.

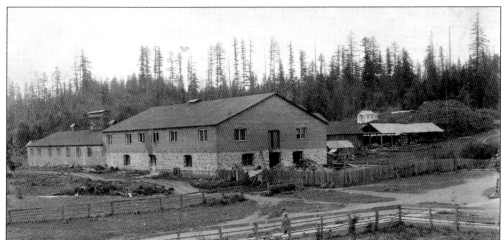

Such a roar of enthusiasm was never heard in Clark County as when Henry Pittock built his paper mill. Cheap homes, reliable wages, and an industrial vision that excited the imagination proved Washington was a land of unending progress. The first buildings of the Columbia River Paper Company, constructed in 1887, included more than 1,200 feet of masonry and all the largest, latest machines west of the Rocky Mountains. (Courtesy Two Rivers Heritage Museum.)

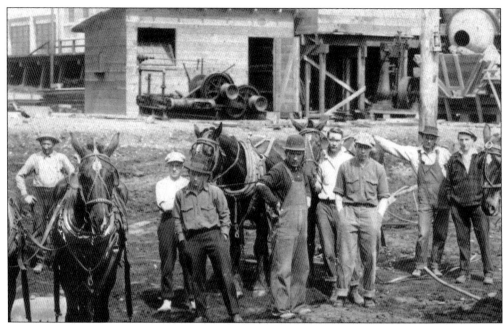

Wagons filled with lumber, brick, and cement (see mixer, upper right corner) were heavy loads for a horse, and crews worked seven days a week for 11 to 13 hours a day. Construction crews, like this one in 1903, carted lumber from the sawmill at Lacamas Lake and rebuilt the mill when the first buildings burned down. (Courtesy Two Rivers Heritage Museum.)

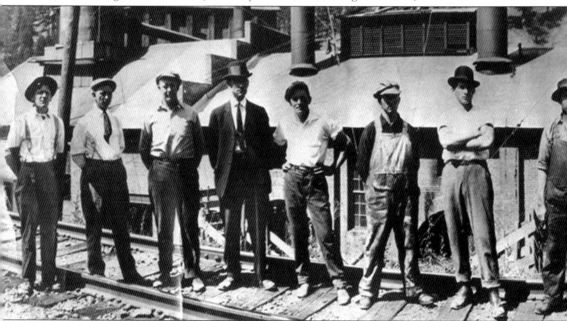

In 1915, Claude Knapp traveled with this crew to build a mill in Floriston, California. He went next to Ocean Falls, British Columbia, to help construct another mill, staying on as supervisor of the finishing room until 1929. He returned to serve in World War I, but the draft board deemed his work in Ocean Falls important to the war effort and thus sent him back to Canada. In all, Claude Knapp worked for Crown Zellerbach for 48 years. When he started at the Camas mill in

At 18, Norman Powell worked in the beater room from midnight until 6:00 a.m., putting material and scraps into a large tub. "It chewed all the paper pulp up, just like beating up eggs until you got it to the right consistency," Powell relates. "I'd get off in time to go home and milk the cow and still go to school." Here mill employees pack finished paper around 1900. (Courtesy Dory Brooking.)

1908, he was earning 10¢ to 15¢ an hour. Seen from left to right are construction crewmen Ernie Cox, Harvey Baxter, M. R. Cox, Sam Cole, Claude Knapp, Bob Dadisman, unidentified, Chas Richart, Bud Baxter, Bill Smith, Pop Moody, Bob Gaines, B. Peterson, Frank Quinn, Al Lewis, and John Christopher. (Courtesy Two Rivers Heritage Museum.)

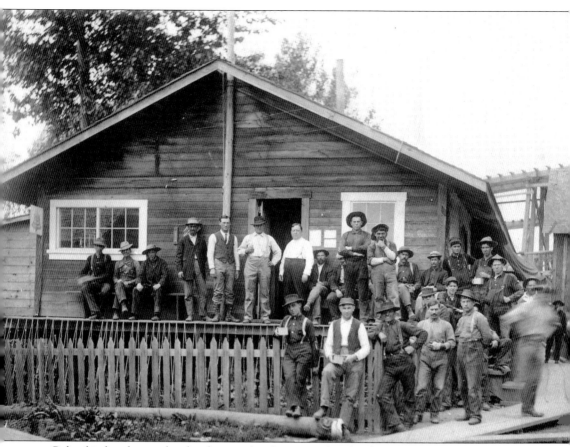

Columbia basalt, an ultra-hard type of rock, was perfect for the construction of the Columbia River Jetty—as it could withstand the violent turbulence of the waves. Speculation at Fisher's quarry began by geologist Henry J. Biddle perhaps as early as 1881, with rock production as early as 1884. Production was in full swing by 1898. That year, Biddle partnered with C. S. Adams, A. L. Merrill, and Daniel Kern to form the Columbia Contract Company, which owned a number of barges and mining interests along the Columbia River. In this *c.* 1915 photograph, the staff stands in front of the firm's office at Fishers. Behind the building are the trestles where railcars filled with rock moved from the cliffs down to the dock. In 1906, according to Biddle, the quarry had "fifteen derricks of about twenty tons lifting capacity, six hundred feet of docks on navigable water, and some eighteen hundred feet of quarry face, averaging about one hundred feet high, within reach of the derricks." (Courtesy Thomas E. Gentry collection.)

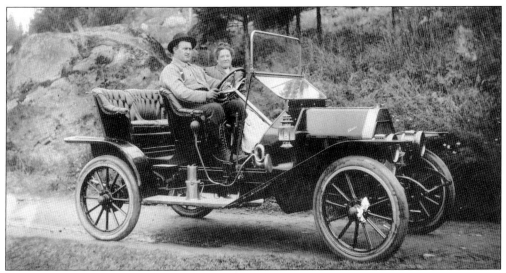

Quarry boss Charles Wallen married John McCarthy Gentry's daughter Kathryn. The couple brought their new Oldsmobile to Riverview Farms in 1911. Perhaps it was Wallen who oversaw the construction of the two dams at the quarry. The water reservoirs and civa-ram pumps, which worked from water pressure alone, might have piped water to the blacksmiths and donkey engine operators. Farmers used them for irrigation through the 1970s. (Courtesy Thomas E. Gentry collection.)

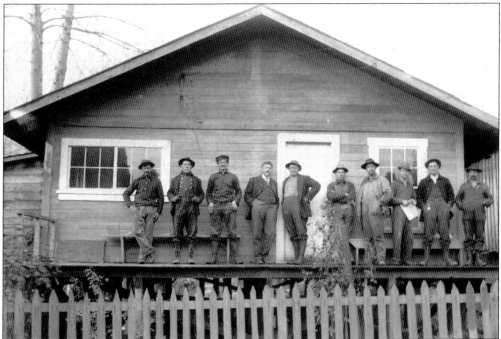

Samuel Kern served as company president in 1913. This photograph, taken about 1910, shows a man in a suit and vest (center). To his right is likely mine superintendent Charles Wallen. This office building is raised on stilt-like supports for mobility and to withstand flooding. James O. Blair supplied rental housing to mine workers along the river. When the river flooded, planks provided walkways between buildings. (Courtesy Thomas E. Gentry collection.)

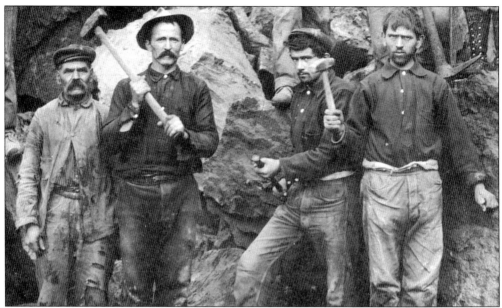

Quarrymen hold hammers and chisels with star-shaped bits, called star drills, around 1910. The man on the right demonstrates the "single jack," in which a single man uses both tools. The two men in the center demonstrate the "double jack"—one man positioning the chisel and the other applying the hammer. They performed this work on hands and knees inside a "coyote hole," a crawl-sized, T-shaped hole bored into the rock. (Courtesy Norman Powell.)

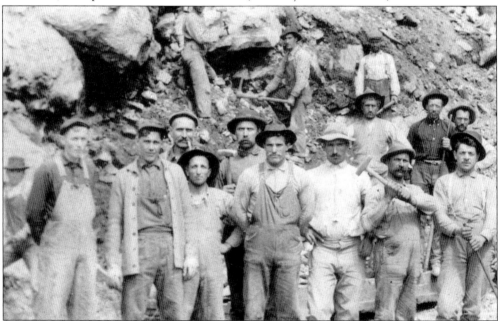

The mine included 12 working pits and four docks. Three pits provided rock for each dock. The pit crews dug a four-foot tunnel into solid rock using hand drills and hammers. They packed the tunnel with powder, a truckload by today's terms, and sealed the opening with rock. Letting off the blast was called "shooting a tunnel." The explosion caused all of Fishers Landing to shake. (Courtesy Two Rivers Heritage Museum.)

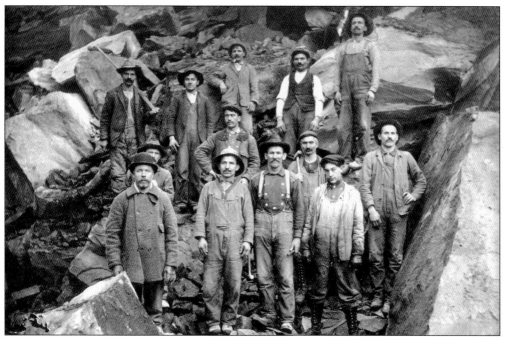

Everett Gentry (first row, far right) worked Pit 6 in 1911 as the fireman who tended the donkey engine. After the blasts, rock spilled loose into the pits. The crews hammered hooks into the sides of the large rocks by hand, then looped choker cables over the hooks. Derricks lifted the rocks out and into waiting cars. The pit boss, John Wydell, stands on the left in the first row. (Courtesy Thomas E. Gentry collection.)

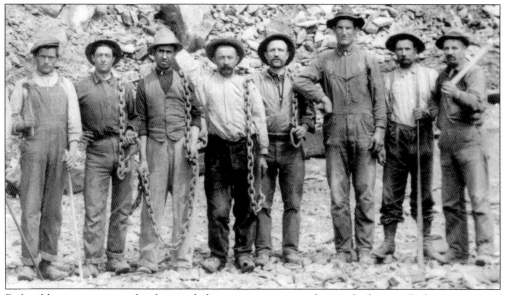

Before blasting, a steam whistle sounded, warning quarry workers to find cover. Only 10 percent of the blasted rock was large enough for jetty use; the rest erupted as shrapnel. After 1908, whistles also warned of approaching trains because the Northbank Railroad ran right through the quarry. A man in a lookout shed sounded the alarm when a train approached, and all work stopped until it passed. (Courtesy Two Rivers Heritage Museum.)

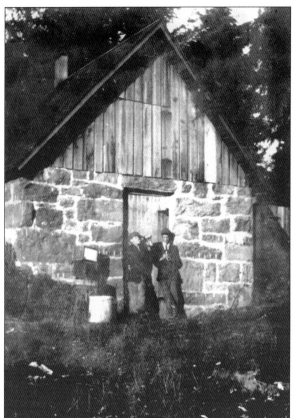

Austrians, Greeks, and Italians, fresh from their overseas journeys, arrived at the quarry to work. Austrian immigrants earned a fabled reputation for masonry, and built this shed, still standing on Evergreen Highway. Using a pintle, they could tap rocks to split exactly to size in what Thomas Gentry described as an "ingenious mystery." May Simmons Gentry used this shed as a pantry. (Courtesy Thomas E. Gentry collection.)

These men outside the Rigging Shack make chokers around 1909. To hand-splice choker cables, they wove the five to seven wires into an "eye," or loop, strong enough to carry volcanic boulders. Putting the eyes on chokers required a certain knack. Men's lives were at stake, as the loops carried rocks over the heads of the workers at the docks and in the pits. (Courtesy Thomas E. Gentry collection.)

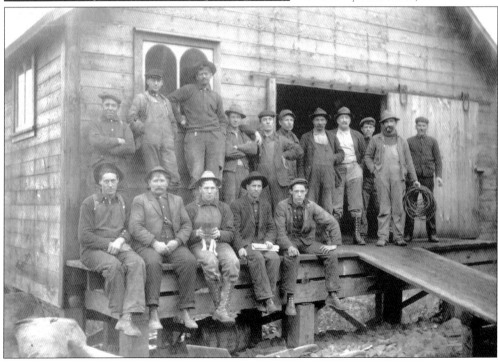

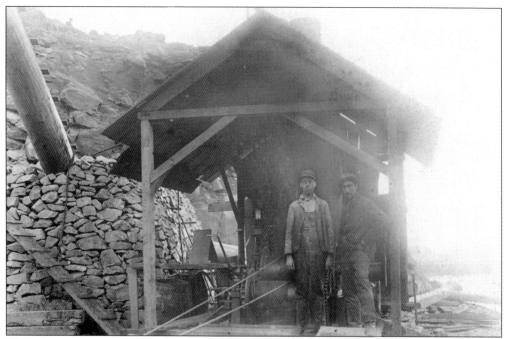

These huts sheltered the donkey engines that powered the derricks. A fireman fed the steam-powered donkey, and an operator controlled the derrick-supported boom, which swung the rock from the pit to a waiting car. The whole operation depended on leverage, and an intricate mound of interlaid stones (left) supported the stiff leg of the derrick. Traces of these mounds can still be found at the quarry site. (Courtesy Norman Powell.)

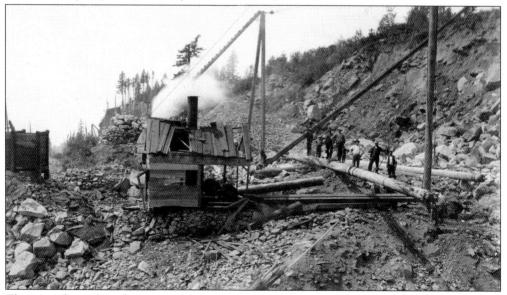

This view shows derrick operations in 1908. The steam engine powered the boom, which swung back and forth. The cable at the end of the boom came down, picked up the rock, and swung the rock to move it. This derrick swung rock over the railroad tracks and down the hill. The crew moved the whole structure when they needed to get closer to the rock pile. (Courtesy Thomas E. Gentry collection.)

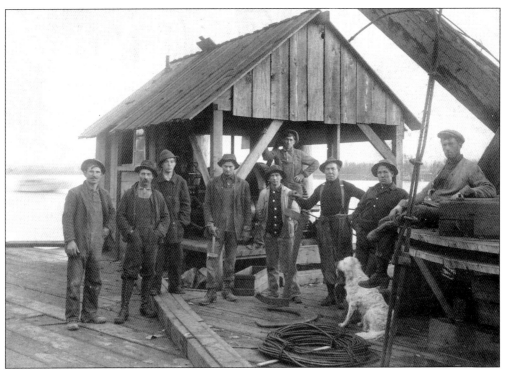

Everett Gentry (third from left) worked on Fisher Dock, pictured around 1912. An employment letter signed by Samuel Kern describes his job as engineer for "steam and gasoline engines, pumping machinery, and plumbing." In the 1930s, the quarry shut down on Friday night. Engineers arrived at 4:00 Monday morning to fire up the donkey engines. A wood fire got the engine started, and then oil maintained its temperature. (Courtesy Thomas E. Gentry collection.)

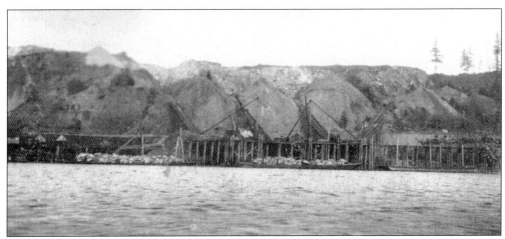

Miners dug from the river inland, carving away the hillside. The first rock was lowered to the river using three-foot cables. The Army Corps of Engineers built trestles for railcars up into the hill, and by 1915, four trestles fed four docks: Upper, Middle, Lower, and New (Fisher Dock). After loaded barges were lashed together, a tugboat pushed them to the mouth of the river. (Courtesy Norman Powell.)

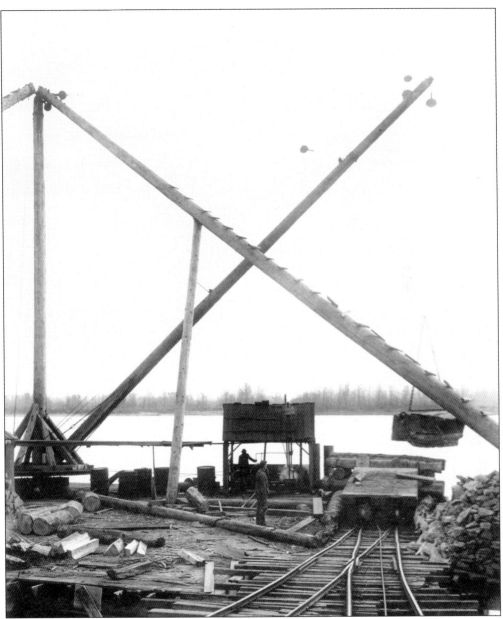

Each dock had a trestle line, including Middle Dock (pictured). Each trestle had rail tracks on which the cars moved back and forth. The cars ran on a system of cables and pulleys. As gravity pulled the heavy, rock-loaded car down the track to the dock, an attached cable pulled the empty car back up the rock pits. At the top of the track, a man operated a bullwheel, which was essentially the giant pulley that controlled the cable and thus the speed at which the heavy cars could descend. The operator stood on a long pole that protruded from the bullwheel platform. The pole served as a brake; by maneuvering the pole with his legs and body, the operator could slow the cars when necessary. Once at the dock, crews used looped choker cables to lift the rocks from cars onto waiting barges. Later a Shay locomotive pulled the heaviest loads. The engine in front would run in reverse to slow the load as it came down the hill. (Courtesy Thomas E. Gentry collection.)

Four quarry barges carried rock to the Columbia Jetty and other coastal jetties. A loaded barge in 1911 measured 140 feet long and 40 feet wide and carried 800 tons of rock. Over the years, Fishers Quarry produced rock and gravel in addition to the giant basalt boulders used for quarry construction. An unidentified family, complete with dog, poses on a loaded barge about 1910. (Courtesy Norman Powell.)

The workday started at 7:00 a.m. and lasted until the barges were full. Towboats such as the *Hercules*, pictured about 1900, the *Henry J. Biddle*, and later the *Sampson*, captained by J. O. Church, pushed the loaded barges downriver. With one barge lashed to each side of the towboat and one in front, the boat and barges made up a spike formation approximately 120 feet wide. (Courtesy Thomas E. Gentry collection.)

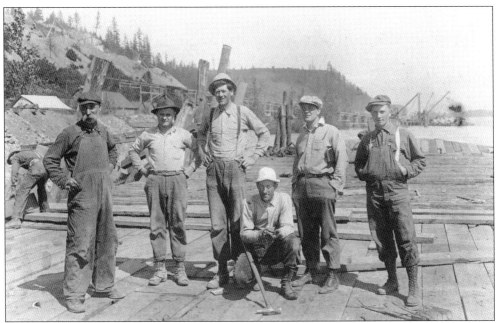

Quarry employees included European immigrants and Mill Plain farm boys. Chinese cooks prepared such foods as rhubarb pie for up to 300 workers. Harley Powell worked at the quarry as a boy, tending dairy cows; he later ran a donkey engine, as did Rolly Hitchcock. Carpenter Ransom Powell (far left) and farm boy Jack Arvidson (far right) were part of a barge construction crew. (Courtesy Norman Powell.)

With its tall trestles, the quarry looks romantic in this c. 1918 Arvidson family photograph. But quarry labor was dangerous. Carl Arvidson Sr. worked in one of the four blacksmith shops. He recalled an incident when a rock fell from a derrick and killed a man. The man's brother rushed over and cut the moneybag from where it was sewn into his dead brother's clothes. (Courtesy Dory Brooking.)

Many local people explored the quarry and the old coyote holes in the cliffs. The four Gentrys—from left to right, Henry, Frieda, May, and Everett—took a number of snapshots in and around the quarry about 1916. For a while, Everett had an interesting job at the quarry. On Friday nights, he took Charles Wallen's boat and transported quarry workers who wanted to spend the weekend in Portland. That was the easy part. The Sunday return trip proved more difficult, as Everett had to go from bar to bar to herd them back together. In general, whisky and quarrying seemed to go together. George Allen put whisky bottles in empty shoeboxes, selling them to the quarrymen who came into the Pumpkin Center store asking for "shoes." For a while, a whisky scow tied up near the quarry dock. Charlie Baab, too, sold bottles filled from a whisky barrel he buried by the river. As the barrel emptied, he would add a little river water to stretch the rest. (Courtesy Thomas E. Gentry collection.)

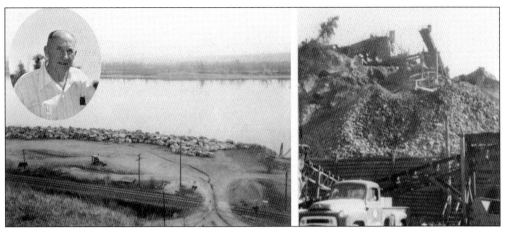

Howard (inset) and Yale Smith started Smith Brothers Contracting in 1935. They purchased Fishers Quarry in 1943 and formed Smithrock Quarries, a multimillion-dollar family enterprise. Smithrock crushed the basalt into riprap and gravel, as seen at right in 1966, and trucks replaced the old barges. Howard's grandsons, the "Smith Boys," ran the crushers. Boulders too large to crush crowded the Columbia River shoreline, pictured at center in 1963. (Courtesy Greg Smith.)

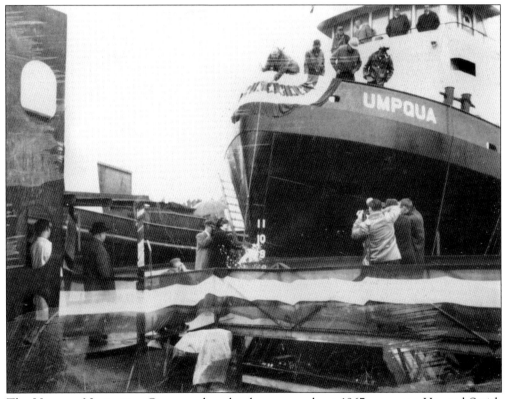

The Umpqua Navigation Company bought the quarry about 1967, an event Howard Smith commemorated with this photograph of the *Umpqua* christening. Umpqua split the quarry, selling the portion east of 192nd Avenue to Washington State and the rest to Peter Kiewit and Pacific Rock Products in 1984. Kiewit became sole owner in 1999. In 2002, Rinker Materials purchased the quarry and sold it to Mexico's Cemex in 2007. (Courtesy Greg Smith.)

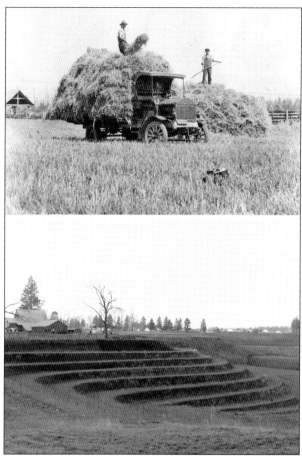

The above hay truck, sitting on the English estate around 1910, sports an American flag waving over the grill. When taxes proved prohibitive in the 1980s, Ferris English quit the dairy business and sold part of the estate to Pacific Rock Products, which mined the sand and gravel deposits there. Now a winery, the old English home and barns overlook the excavation bowl (below). (Above, photograph by Carl English, courtesy Gene English; below, photograph by R. Fairhurst, 2008.)

This eastward view of the Columbia Tech Center, now under redevelopment, shows the bowl left behind from the excavation of sand and gravel along Mill Plain Boulevard. To the left, a retirement community nears completion. The back wall of Home Depot and Walmart, with Wafertech above in the distance, can be seen at left center. Homes and schools rim the bowl to the south and east. (Photograph by Melissa Fairhurst.)

*Five*

# PIONEER SCHOOLS COME OF AGE

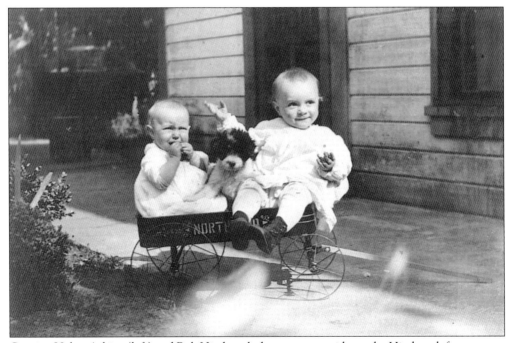

Cousins Helen Atkins (left) and Bob Hitchcock share a wagon ride on the Hitchcock farm, across from today's English Rifle Range, in 1915. Bob Hitchcock was among those who campaigned for the new Union High School to bear the name of its early predecessor. A member of the class of 1932, Bob lettered in baseball, football, and basketball. His letter is on display at the new Union High School. (Courtesy Bob Hitchcock.)

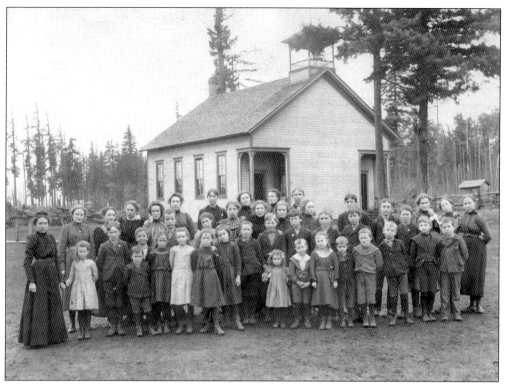

The first schoolhouse was built on Jacob Duback's land in 1857. Students included the Simmons, Maxon, Knight, Goodwin, Martin, and Zeek families, a Leiser, George W. Bush, and 26-year-old Alexander Coffey. The second Mill Plain schoolhouse, built on Blair property, still stands on the northeast corner of Mill Plain and 164th. The surrounding landscape, however, has changed considerably. Those pictured here around 1895 include Hannah and Roy Laver. (Courtesy Union High School.)

Excerpts from the school ledger show individual marks for some of Mill Plain's first students. The spelling list (left) makes note of the strongest spellers in 1858. An interesting grading scale was in place for attendance and conduct. The excerpts from 1859 (right) show a grading scale of Very Good, Good, Middling, Bad, Very Bad, and Worthless. Happily, all the students earned a Very Good rating. (Courtesy Union High School.)

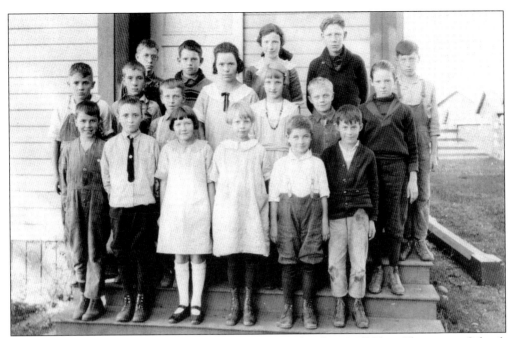

The children of these Mill Plain students would attend today's Mill Plain Elementary School, constructed in 1954 with a real playground slide, courtesy of Fishers Grange. Pictured about 1923 are the following, from left to right: (first row) Johnnie English, Bob Hitchcock, Mary Schoenig, Billy Marchbank, Raymond Groth, and Verle Ferguson; (second row) Charles Clemmons, Stan Manary, George Stein, Teatha Savage, Margaret Duback, Bud Hessie, and Norman Duback; (third row) unidentified, Ralph Forgey, Eliza Duback, and two unidentified students. (Courtesy Pat Forgey.)

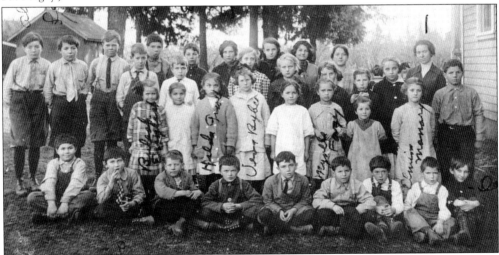

Mill Plain students pose outside the schoolhouse in 1913. Students identified, from left to right, include (first row) unidentified, George McQueen, six unidentified, and Dane Webster; (second row) Beulah English, unidentified, Helda Groth, Vera Bybee, unidentified, Myrtle Forgey, unidentified, Elmina Manary, and Sam Wright; (third row) six unidentified, Ida Kronberg, and teacher Lulu Ernest; (fourth row) Alvin Carpenter, Leo Carpenter, unidentified, Archie Rodgers, Ernie Sampson, Edna Webster, Alberta Blair, Mildred Bybee, and unidentified. (Courtesy Pat Forgey.)

The Harmony District comprised the northern part of today's Fishers Landing. In 1885, George A. Whipple built the first Harmony School on his 200-acre farm and taught the initial class of students. The first Boy Scout troop in Clark County was organized in the Harmony area with Lloyd Whipple serving as scoutmaster. The first Harmony School doubled as a Sunday school. (Courtesy Mill Plain United Methodist Church.)

In the early days, the school year lasted just three months, and teachers were paid $100 for the term. In 1903, the Harmony School had 29 students from 15 families, including the Strunks, Whipples, Spricks, Peebles, and Davids. Today's facility opened in 1991 and currently enrolls 700. Harmony also has a student choir. The original Harmony School building still stands, now used as a residence. Go Huskies! (Photograph by R. Fairhurst, 2008.)

Class portrait day at Fishers School in 1902 has Gordon Bellinger (left) and Harley Powell posed in front, kneeling as if they are playing peg. The others are as follows, from left to right: (first row) teacher Ida Cates, Myra Powell, Edred Griffith, Grace Snelling, Willard Allen, and Ethel Scotten; (second row) Willie Tomlinson, Prudence Powell, May Simmons, Myrtle Phelps, Althea Scotten, Anna Belle Powell, Florence Snelling, Wilbur Bellinger, and Leonard Timmons; (third row) Mortimer Simmons, Ed Ziegler, Carl Scotten, Crommy Danforth, Grace Timmons, Martha Noa, Hazel Allen, Julia Ziegler, Maud Scotten, Maggie Tomlinson, Bertha Tomlinson, Bertie Heaton, and Leon Snelling; (fourth row) Clarence Scotten, Bill Ziegler, Lester Phelps, Saul Fisher, May Ziegler, Earl Johnson, Edna Fisher, Lillie Ziegler, Sadie Allen, and Florence Tomlinson. (Photograph by Meiser; courtesy Norman Powell.)

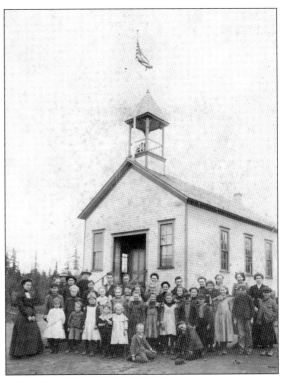

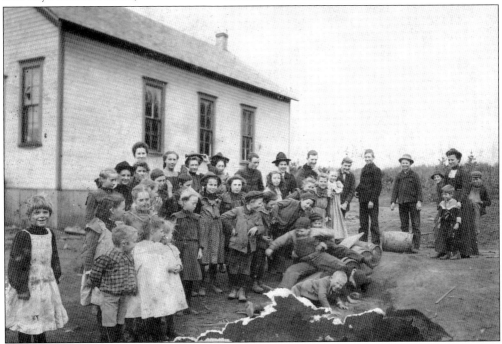

The careful line assembled in the previous photograph degenerates into a good-natured tussle here, with Harley Powell under a squirming pile. Fishers School opened in 1898 on Solomon Fisher's claim, where Fisher Road met Fisher Hill, near the Grange and church buildings. (Photograph by Meiser; courtesy Norman Powell.)

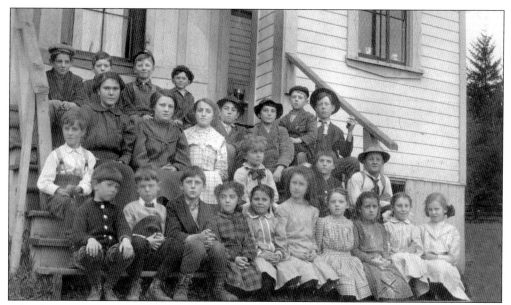

Schoolteacher Mary M. Holst took this photograph of Fishers School students about 1919, including Norman Powell, Billy Simmons, and Henry Tuttle. Fishers School pupils sometimes included the children of quarry workers or indeed the immigrant workers themselves, who sought to learn English. Fishers had no outdoor play equipment. During recess, the kids dug holes in the dirt or ate their lunches while balancing on the fence rail. (Courtesy Norman Powell.)

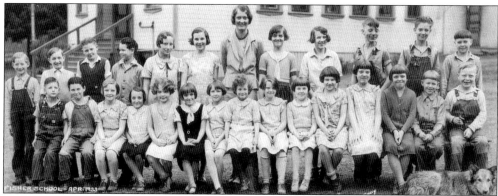

Thomas Gentry's younger brother Carlyle "Bill" Gentry (top row, far right) attended Fishers School in 1933. Educator Ruth Henning taught at Fishers through the 1930s and 1940s. Thomas Gentry remembers a big, mechanical, brass machine at the school saying: "It had the sun and moon and then when you turned the crank, the moon would get over the sun and explain how [an] eclipse worked." (Courtesy Thomas E. Gentry collection.)

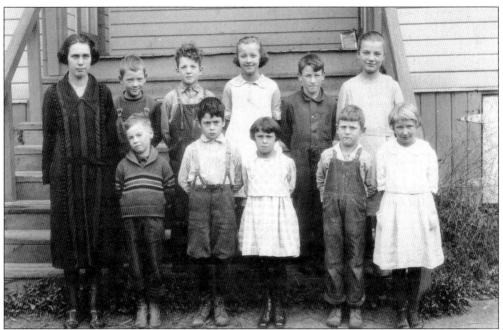

The Fishers School central classroom served the first through sixth grades, with a small room behind for the seventh and eighth grades. Shown about 1921 are the following, from left to right: (first row) Tom Gentry, Raymond Bowers, Helen Mariott, Robert Fisher, and Vida Hewett; (second row) teacher Viola Brooks, Fred Arvidson, Hershel Tuttle, Mildred Hood, Joe Griffith, and unidentified. Mildred Hood, who lived on Government Island, came to school by rowboat. (Courtesy Thomas E. Gentry collection.)

The new Fishers Landing Elementary School opened in 1996 to serve more than 650 students. It is a good deal more modern than the old one. Thomas Gentry remembers that in the middle of the old schoolhouse was a giant woodstove used for heating. For a fire alarm, the teacher would grab up the iron poker and whack it on the stove. (Photograph by R. Fairhurst, 2007.)

The Grass Valley School was constructed on Knapp land, on today's Southeast 217th Avenue and Twentieth Street, in 1868. Students spent cold winters in the original log building, as the wind blew in through the holes they poked in the mud-chinked walls. In 1914, a brick schoolhouse (pictured) replaced the log structure. After 1939, the Grass Valley District consolidated with Camas, and students attended Lacamas Elementary. (Courtesy Two Rivers Heritage Museum.)

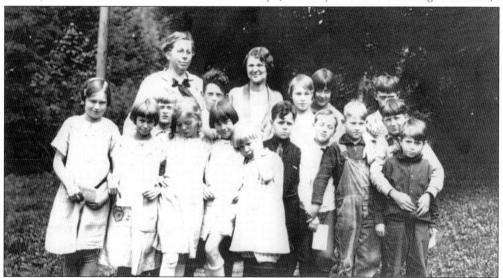

The first Prune Hill institution, Riverview School was established on the Joel Knight donation claim on the Columbia River in 1888. Shown from left to right are the following: (first row) Eleanor Scholl, Vera Lewis, Fred Hennings, Mildred Martin, ? Mann, Etta Martin, Leo Gullnet, Carl Pond, Franklin Ackerman, unidentified, and Donald Lewis; (second row) Miss Whipple, David Lister, Mrs. Taylor, Marion Ackerman, Delia Gullnet, and Myron ?. (Courtesy Two Rivers Heritage Museum.)

The pioneer Riverview School building was moved uphill through thick woods to make way for the Northbank Railroad around 1905. Prune Hill School, constructed in 1920 for $6,000, eventually replaced Riverview and featured a large classroom (pictured), small stage, basement, kitchen, and boys' and girls' outhouses. In 1923, Prune Hill students sponsored a pie social to raise money for a piano. (Courtesy Two Rivers Heritage Museum.)

More than 600 students attend the Camas School District's new Prune Hill Elementary School, which opened in the fall of 2001. Students in this affluent Camas school are well versed in computer technologies. In an ironic historical turnabout, they now learn "what is a farm?" Students study farms by building models, complete with animals and barns. The unit culminates in June with a trip to a real working farm. (Photograph by R. Fairhurst, 2008.)

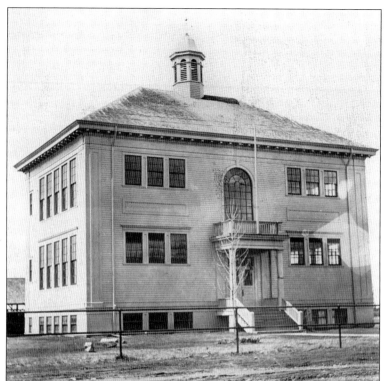

The old Union High School, seen about 1921, stood near the northwest corner of 164th, where the 1954 Mill Plain Elementary School is located today. Mattison and Lucinda Blair, who owned a farmhouse and prune dryer at the current site of Target, donated land to build the school in 1910. In a time when high schools were expensive luxuries, seven smaller districts joined together to build Union High School. (Courtesy Gene English.)

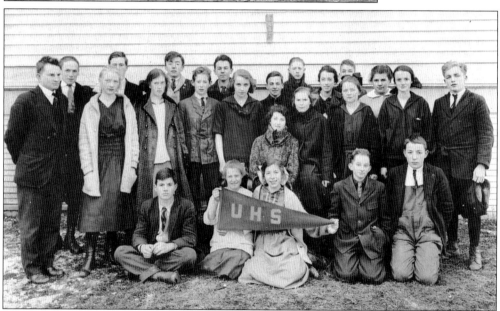

Union High students share a banner day around 1918. Pictured from left to right are the following: (first row) Sam Wright, Dorothy Duback, Mildred Bybee, Dave Webster, and Leo Carpenter; (second row) Velma Allen, Dorothy ? , Charles Tiffney, Ida Kronberg, Agnes Wechner, Shellie Slyter, Olive Blair, Clara Powell, Eva Strunk, Alberta Blair, and Lauren Forgey; (third row) Kenneth Blair, unidentified, Alvin Carpenter, "Doc" David, Joe Schmidt, Hugh Eperson, and unidentified. (Courtesy Pat Forgey.)

Many Union High School students were active and athletic, both at home and at school. Students helped run family orchards and farms, and a few rode to school on horseback. The girls' basketball team (above) became the area champion in 1921. Members of the 1922 boys' basketball team (below) were, from left to right, Carl English, Pinky Groth, Joe Schmidt, Frances Groth, unidentified, Theron Beveridge, and Hugh Eperson. (Above, courtesy Gene English; below, courtesy Pat Forgey.)

Members of the 1925–1926 football team are pictured here, including Roy Carpenter, Percy Carpenter, and right guard Robert "The Bluffer" Fisher, all of whom lettered. Robert Fisher also lettered in track. The son of Saul Fisher, Robert graduated in 1926 and was the last of the Fishers Landing Fishers. Many local families, however, are descended from, or connected to, Solomon, Ann Jemima, Rachel, or Job. (Courtesy Union High School.)

Ida Duback's family, among the first to settle Fishers Landing, was a strong and consistent supporter of education. In 1926, the year Ida graduated, R. E. Duback served as clerk on the school board with chairman G. E. Whipple and members W. Frymire and R. L. Wechner. Ida Duback was nicknamed "The Chatterbox" on the "Who's Who" page of the 1926 *Wauna* yearbook. (Photograph by NuArt; courtesy Union High School.)

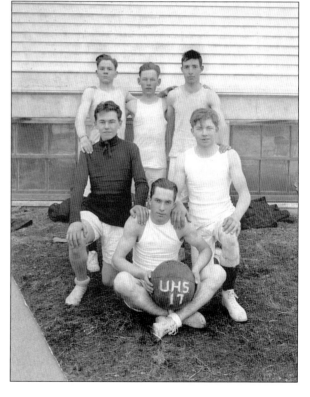

The boys' basketball team of 1917 included Otis Blair (first row, center), Ferris English (third row, left), and Pinky Groth (third row, center). Union High upperclassmen raised money for extracurricular activities through projects like selling peanuts to pay for the junior-senior prom. On Peanut Day, chaos ruled as shells covered the floors, and peanut fights ensued in the hallways. (Photograph by Oregon Commercial Studio; courtesy Gene English.)

Dorothy Whipple, shown in 1926, came from one of the classiest, best-educated, and most-respected families in Fishers Landing. Her great-grandfather was Salmon Creek pioneer and legislator Samuel R. Whipple, who was related to William Whipple, one of the signers of the Declaration of Independence. In 1876, Samuel's son George settled on 200 and then 400 acres in Fishers Landing's Harmony District and ran a Holstein dairy farm. (Courtesy Union High School.)

Vida Groth, an upperclassman in 1926, was active in drama, Glee Club, operetta, and was the enthusiastic president of the Girl Reserves. The Reserves organized pie and candy sales and sponsored an annual boy-girl party in the gym featuring a pretend wedding. Vida's German grandparents Henry and Wilhelmina settled northeast of 164th Avenue and First Street. Her parents, Henry and Annie, were married by A. J. Remington at Fishers Landing. (Courtesy Union High School.)

Union High School produced a few plays each year, including this 1927 faculty-sponsored performance, *The Time of His Life* by C. Leona Dalrample. The actors were, in no particular order, Velton Davis, Ruth Rossman, Carl Brandis, Ruth Forgey, Clifford Stickney, Dorothy Dickinson, Percy Carpenter, Lyman Rohrer, Walter Friberg, and Charles Groth. Elinor Whipple provided music during intermission. (Courtesy Union High School.)

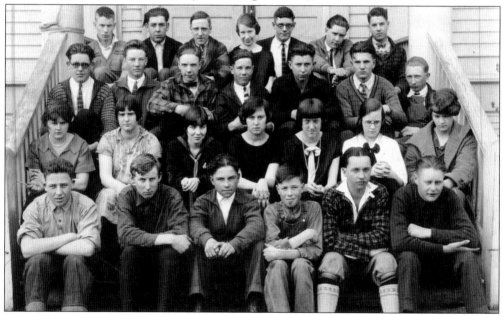

Elinor Whipple (second row, second from right) was voted May Queen for the class of 1928. Her classmates were Hugh Adams, Ross Benninghoff, Maynard Bozlee, Carl M. Brandis, Francis Britton, Grace Burns, Vernon Carlson, Percy Carpenter, Gerald Craig Sr., Rena Craig, Mary Davis, Velton A. Davis, Dorothy Dickinson, Lester Duback, Alice Ellithorpe, Monte Emery, Ruth Forgey, Walter Friberg, Charles Groth, Ethel Hall, Royal E. Hall, Don Hughey, Bill Jones, George Jossis, Sigfrid Jossis, Edith Lippe, Evelyn Love, George "Edward" Mill, Walter Patterson, Helen Pattison, John "Walter" Peterson, Sidney Pickett, Victor "Marion" Rea, Edith Robinson, Wilmer W. Robinson, Clinton Rohrer, Lyman Rohrer, Ruth Rossman, Donald Smith, Clifford Stickney, Lorenzo Strunk, Conrad Sullins, Rufus Tobey, Ross Trieman, Ross Tuttle, Kenneth Tweed, Ida Yoland Wey, and Arthur Williams. (Courtesy Union High School.)

These four students, posing on the back steps of the old Union High building around 1924, probably do not include Robert Fisher or Harry Friberg. Fisher was ribbed good-naturedly for lack of preparation and "drawing cartoons in economics." The 1926 *Wauna* also predicted that if "most athletic" Harry Friberg should perish, Algebra II would be the cause. Vida Groth, however, named "most conscientious," had a reputation for efficiency and organization. (Courtesy Union High School.)

The new Union High School opened in the fall of 2007, featuring 14 computer labs, robotic design equipment, and a top-notch athletic center. Its 68 acres come with a distinct pioneer history; they were once part of the Lorenzo and Edith Strunk 100-head dairy farm. Union High School is included in today's rapidly growing Evergreen School District, boasting an annual operating budget of over $200 million. (Photograph by R. Fairhurst, 2008.)

Epworth Sunday School met in the first Mill Plain schoolhouse (pictured) in the 1890s. From that class came the Epworth Church, built in 1900 on Blair land on the northeast corner of Mill Plain and today's 164th Avenue. Charter families included the Allens, Blairs, Cooks, Hitchcocks, Lavers, and Nicholses. Rev. F. E. Smith dedicated the church in 1903. (Courtesy Mill Plain United Methodist Church.)

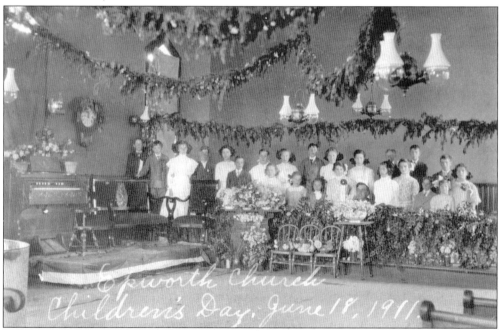

Epworth youth celebrate Children's Day in 1911. On this day, the children of the church participate in many aspects of the service, including leading prayers and providing worship music. These Epworth children all wear formal suits and dresses, and for the occasion of the photograph, flowers and garlands are strewn around the church. The man seated at center is likely Reverend Rossman. (Courtesy Patsy Ferguson Sleutel collection.)

When the congregations at Epworth Church and Harmony Church combined in 1921, even the buildings were joined. Members literally moved the Harmony building and annexed it to the back of the Epworth Church on Mill Plain. Combined, the two formed the East Mill Plain Methodist Episcopal Church. The building was torn down in the 1990s, and the site now holds a restaurant. (Courtesy Mill Plain United Methodist Church.)

Norman Powell attends his cousin Caroline's wedding at the East Mill Plain Church in 1942. His grandfather Ransom Powell, a carpenter, helped build the Harmony Church building. The wedding party includes, from left to right, Irene Crites, Norman Powell, bride Caroline Crites, and groom ? Toivenen. Today's Mill Plain United Methodist Church was constructed on Mill Plain near 157th Avenue in 1983. (Courtesy Norman Powell.)

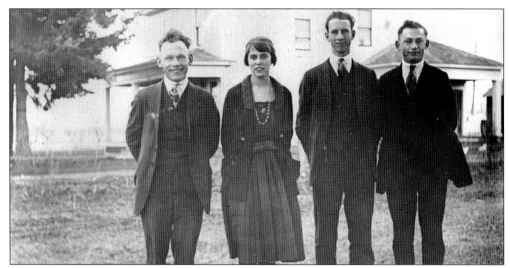

Many Fishers Landing families were active with local ministries, and some even went overseas. The Groths came to Mill Plain starting with Henry C. Groth, who married Annie Elliot in 1893. Of their seven children, three—Vida, Claude, and Francis—became ministers, and their grandson Leon Strunk became a missionary in Brazil. Carl English photographed these four Groth siblings, with Pinky at left, on the Groth farm about 1920. (Courtesy Gene English.)

Inspired by the grotto in Medjugorje, Yugoslavia, Smithrock owners Rod and Beverly Smith built the Queen of Peace Grotto in the Fisher Creek area of the rock quarry in 1987. The Fishers grotto featured numerous natural springs, European statuary, and a bronze memorial for Mark Smith, who drowned in 1992. This photograph of Lourdes Grotto in Switzerland graced a penny postcard in 1905. (Library of Congress.)

YOUR · TEACHER · is glad to COMMEND · you · for · prompt Attendance · and · good Lessons. on the Sundays · marked · below

Clara Caulder Teacher

To Sadie Blair.

SUNDAYS of the 4th Quarter 1892.

| 1st | 2d | 3d | 4th | 5th | 6th | 7th | 8th | 9th | 10th | 11th | 12th | 13th |
|-----|-----|-----|-----|-----|-----|-----|-----|-----|------|------|------|------|
|     |     |     |     |     |     |     |     |     |      |      |      |      |

PRESS OF HARRIS JONES & CO. PROVIDENCE, R.I.

Sadie Blair attended Sunday school at the Mill Plain schoolhouse, then at Epworth Church, and finally in the Harmony annex at East Mill Plain United Methodist Church. Good attendance was rewarded with colorful cards, like this one given to Sadie Blair by Sunday school teacher Clara Caulder in 1892. Sadie would earn another card later, from teacher Lucy Caples. (Courtesy Patsy Ferguson Sleutel collection.)

Early Methodist churches were served by traveling pastors called circuit riders, who visited a regular round of churches, rotating each Sunday. The Camas United Methodist Church, built on the corner of Fourth Avenue and Everett in 1891, was part of the Fishers Circuit. Founding church members included the Knapp family. This structure was razed in 1950 and rebuilt on Fourteenth Avenue. (Photograph by Charles Hoyt; courtesy Two Rivers Heritage Museum.)

Built in 1912, Fishers Church (center) stood next to Fishers School (far right) on the top of Fisher Hill. Carl Arvidson Sr. would remember Sunday school teacher Mrs. Black as a mainstay of the church and "a real nice woman." The Blacks were also active in the Fisher Grange. The church burned down, and the foundation was remade into a home that still stands today. (Courtesy Norman Powell.)

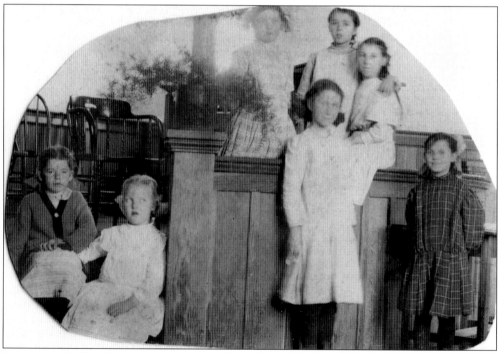

Youth and children's groups gathered regularly for meetings and activities at Fishers Church, including the Golden Hour Club for little girls, seen around 1906. Club members included the following, from left to right: (first row) Helen Duback and Lety Tuttle; (second row) Catherine Wayne and Martha Rhodes; (third row) Ruth Scotten, Clara Powell, and Grace Rhodes. (Courtesy Norman Powell.)

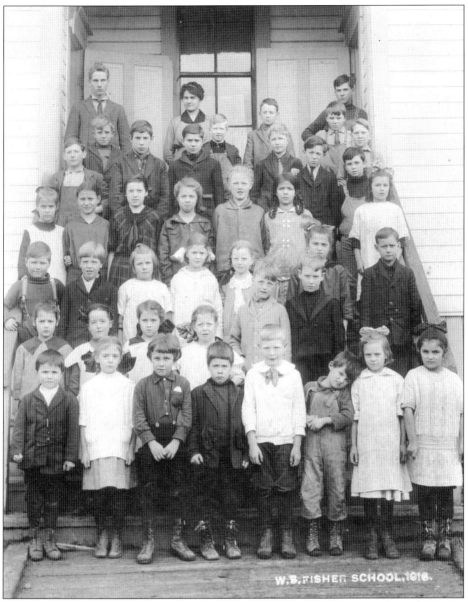

These Fishers Landing schoolchildren, pictured in 1916, oversaw tremendous changes. The children of pioneers, they were born in a time when Fishers was a thriving town and river port, and life "on the plain" included fervent county and state politics. They were infants when the railroad came. They saw the height—and the decline—of the prune industry, and during their lifetimes, they watched Fishers and Mill Plain become the "sleeping giant" referred to in the 1980s when, with the construction of the Interstate 205 bridge, the boom was on again. A few lived to see the next transformation—of sleek suburban neighborhoods and suburban shopping. But long gone now are the Fisher siblings who traveled west. What once belonged to Silas Maxon, Adam Fisher, and Napoleon McGillivray is now Cascade Park. Gone too is Solomon Fisher's landing on the Columbia. Where the Duback, Bybee, Blair, and Atkins families farmed, shops, theaters, and restaurants have sprung up. Today Fishers Landing is a newly bustling place, with a new generation of schoolchildren to watch over it. (Courtesy Bob Hitchcock.)

ACROSS AMERICA, PEOPLE ARE DISCOVERING
SOMETHING WONDERFUL. *THEIR HERITAGE.*

Arcadia Publishing is the leading local history publisher in the United States. With more than 4,000 titles in print and hundreds of new titles released every year, Arcadia has extensive specialized experience chronicling the history of communities and celebrating America's hidden stories, bringing to life the people, places, and events from the past. To discover the history of other communities across the nation, please visit:

# www.arcadiapublishing.com

Customized search tools allow you to find regional history books about the town where you grew up, the cities where your friends and family live, the town where your parents met, or even that retirement spot you've been dreaming about.